Bristol

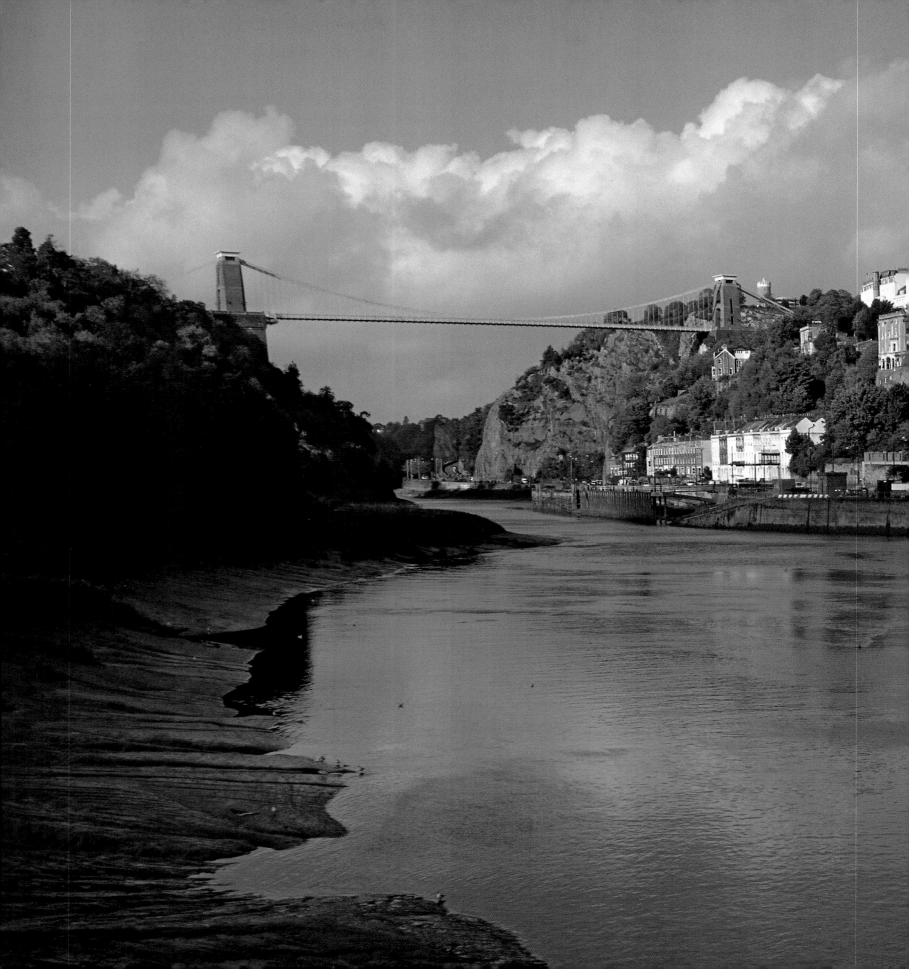

Bristol
City on the Edge

Neill Menneer Tim Mowl

F

FRANCES LINCOLN LIMITED

PUBLISHERS

www.franceslincoln.com

Frances Lincoln Ltd
4 Torriano Mews
Torriano Avenue
London NW5 2RZ
www.franceslincoln.com

First Frances Lincoln edition 2006

British Library Cataloguing in Publication data
A catalogue record for this book is available from the
British Library.

Printed and bound in Singapore

ISBN 10: 0-7112-2570-2
ISBN 13: 987-0-7112-2570-1

9 8 7 6 5 4 3 2 1

contents

a question of definitions

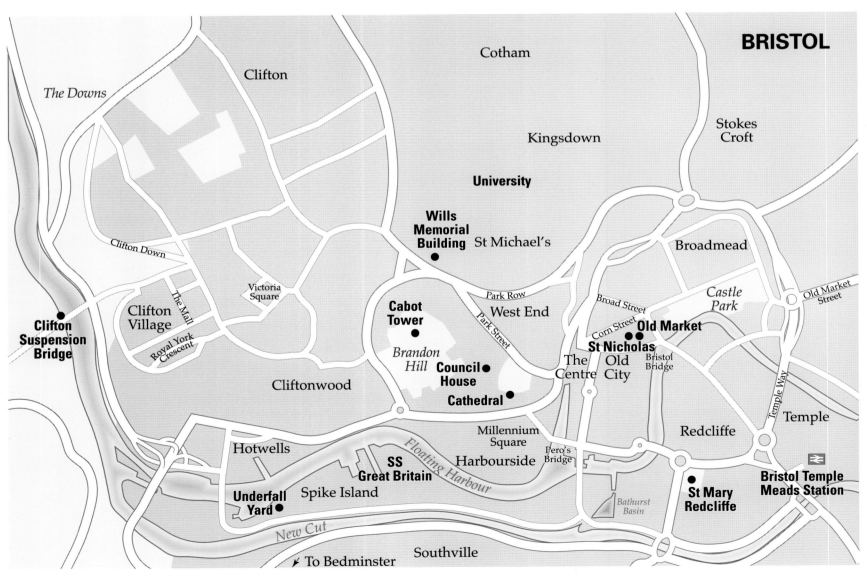

BRISTOL

Cotham

Clifton

The Downs

Kingsdown

Stokes Croft

University

Wills Memorial Building

St Michael's

Broadmead

Clifton Down

Victoria Square

Cabot Tower

Park Row

West End

Broad Street

Castle Park

Old Market Street

Clifton Suspension Bridge

Clifton Village

The Mall

Royal York Crescent

Brandon Hill

Park Street

Corn Street

Old Market

St Nicholas

The Centre

Old City

Bristol Bridge

Cliftonwood

Council House

Cathedral

Temple Way

Millennium Square

Redcliffe

Temple

Hotwells

Floating Harbour

Pero's Bridge

SS Great Britain

Harbourside

Underfall Yard

Spike Island

Bathurst Basin

St Mary Redcliffe

Bristol Temple Meads Station

New Cut

To Bedminster

Southville

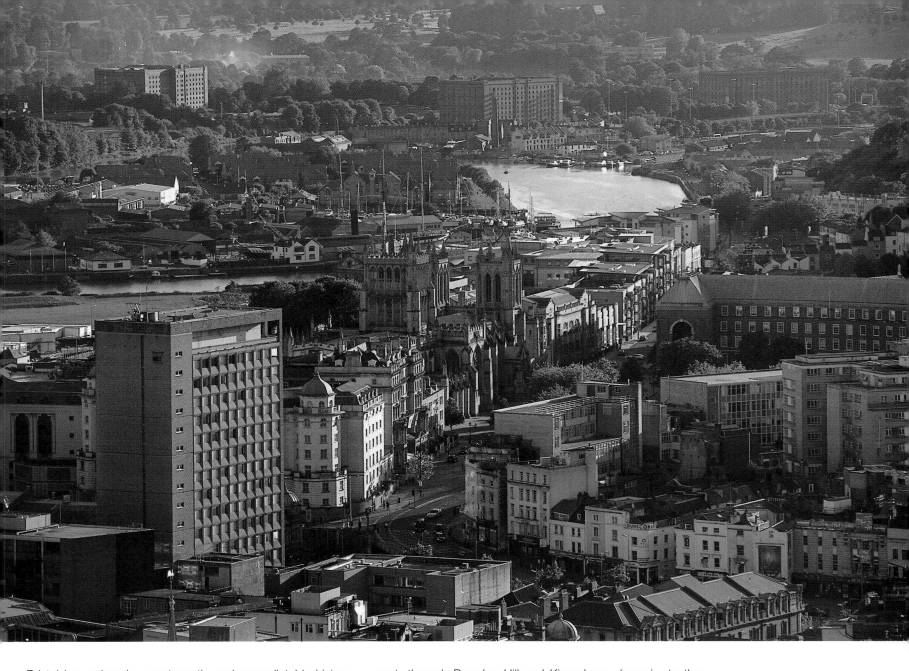

Bristol has enjoyed a most erratic and unpredictable history. Probably the most significant fact in its record is that it was made a county, by royal charter of King Edward III, in 1373, a whole 169 years before 1542, when Henry VIII, casually and accidentally, made it technically into a city with its own improvised, ingenious, but unsatisfactory cathedral. So it was a county first and a city afterwards. Bristol is a diverse area of land, scarp, edges and valley rather than a conventional urban centre.

What makes this odd county-city so rewarding in its architecture and its linear development is the way the Old City, down where the rivers Avon and Frome come together at the Tramway Centre on St Augustine's Reach, has been overtaken and, to be unkindly honest, outclassed by its suburbs out on the topographical edges that hang over it on a long dramatic line of steep hillsides from Clifton, the suburban sublime in the west, through Brandon Hill and Kingsdown closer in, to the refined artisan simplicities of Totterdown in the east. It will seem to be playing with words, but the city is not so much Bristol and Clifton as Clifton and Bristol. Though their dual association remains most satisfying, the child Clifton has exceeded and out-pointed the parent Bristol.

The Old City has its charm of churches and a wonderful Victorian financial district that is a wildly eclectic reminder of what London has lost. But at Clifton and along the edges something far more precious has evolved: a late, liberated classicism of 1785–1850 became a purely Romantic creation when its crescents, parabolas and squares were wreathed around wild bluffs of rock and tangled woodlands on the very brink of savage cliffs. Nothing in neighbouring tourist-ridden Bath or in Edinburgh's eighteenth-century New Town has the architectural poetry, the improbable visual confrontations, of Clifton.

ABOVE **A satisfying dockyard aesthetic despite an absence of planning.**

RIGHT The Cumberland Basin, with a 1960s road system running past bonded warehouses for storing tobacco.

FAR RIGHT A one-in-six hillside enlivens even dull late-Victorian housing.

BELOW RIGHT William Venn Gough's Cabot Tower (1896–8) on the strategic open space of Brandon Hill.

BELOW The Cathedral on one side, The Centre on the other, and bland office blocks in between

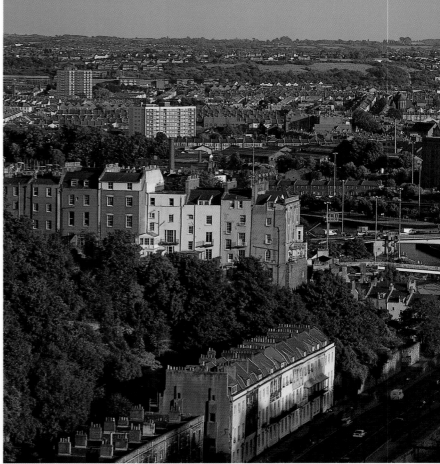

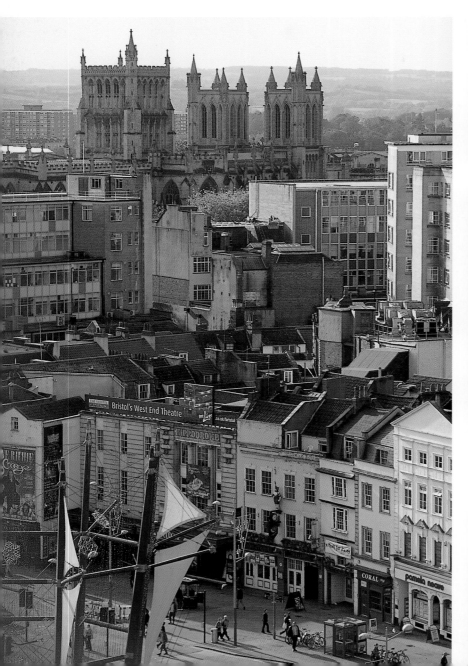

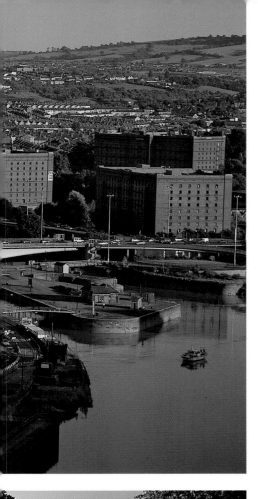

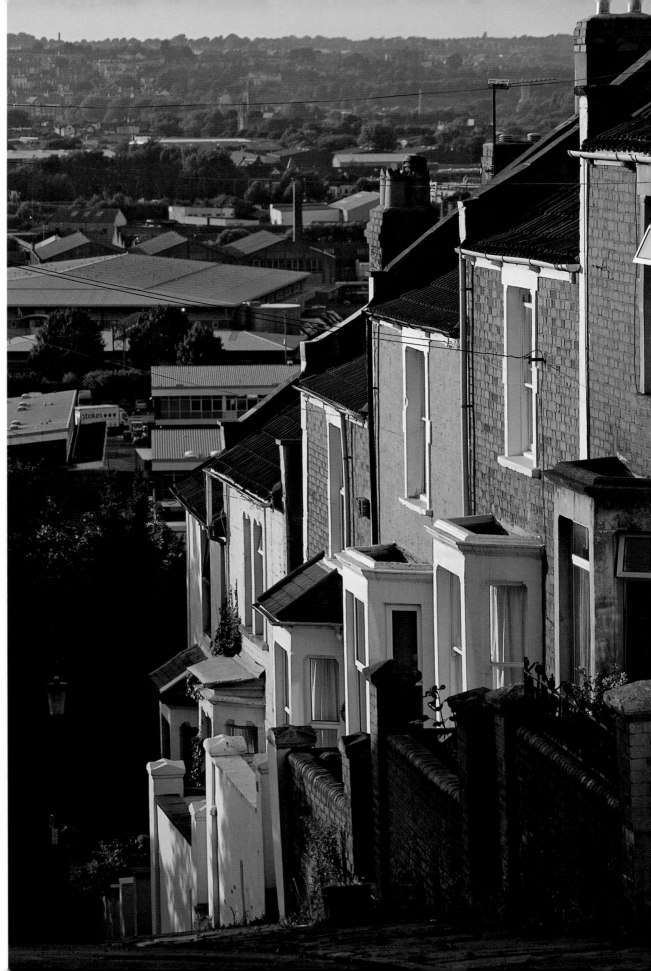

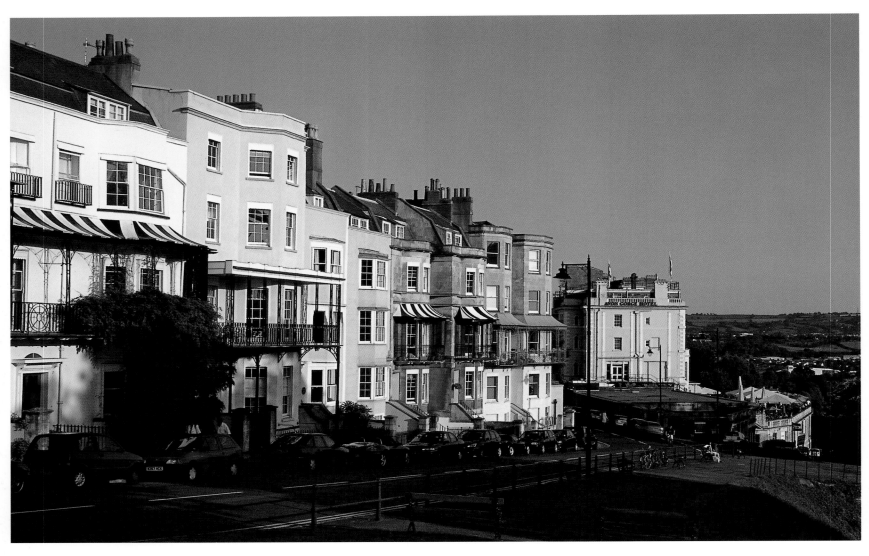

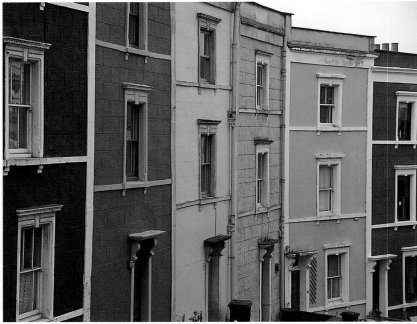

CLOCKWISE FROM TOP **1780s lodging houses on Sion Hill; riotous seaside colour enlivening the Cliftonwood terraces; delicate Regency detail at Freeland Place.**

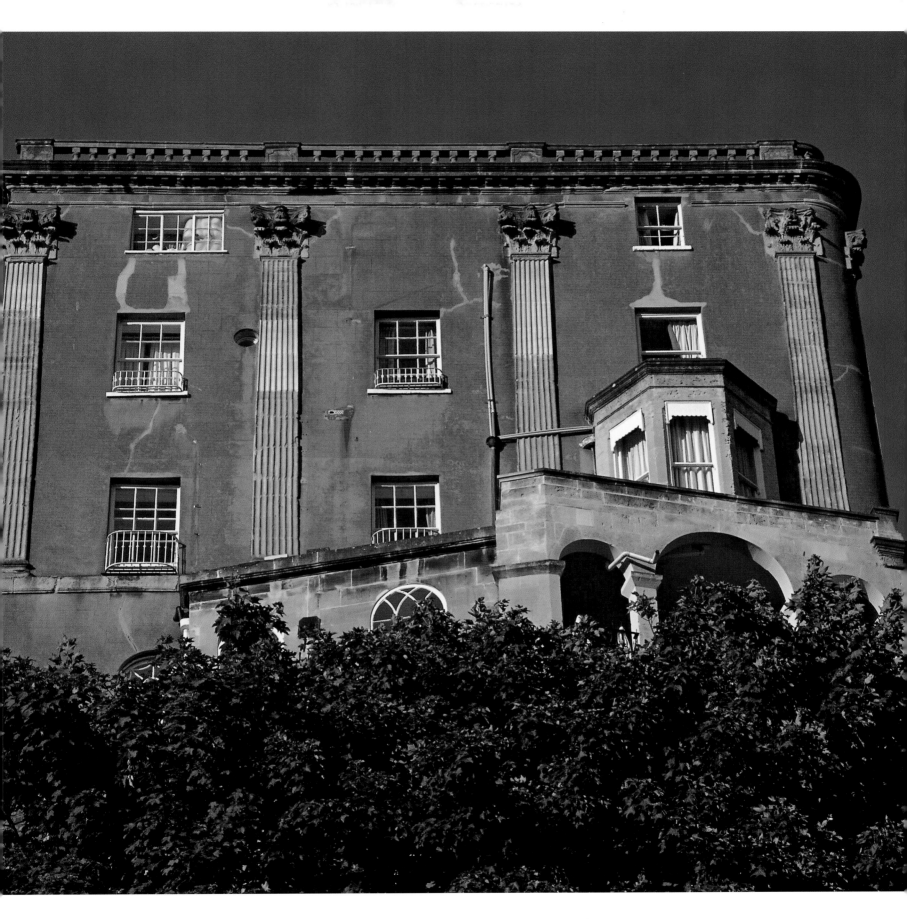

ABOVE Windsor Terrace is set directly above the Gorge, with giant Corinthian pilasters that fail to support its cornice.

What is so serendipitous about this aesthetically divided community is that it is largely the result of maladministration, a thousand years of incompetence by corrupt, or more often simply foolish, West Country locals from the time of the Viking invasions in the ninth century to the post-war planning decisions of the 1940s and 1950s and even later. There is something in the air, or possibly the ale. In Saxon times, despite the protests of St Wulfstan, Bristolians ran a white slave trade with Ireland. During King Stephen's reign the men of Bristol terrorized neighbouring villages 'like a pack of hungry dogs'; and in the eighteenth century, of course, they ran the notorious three-cornered trade, taking brass and glass ware to West

Africa, slaves to the West India sugar plantations and rum back to Bristol. Occasionally the city even stopped bothering to have a bishop, and for a few years Gloucester took on the burden of so much un-Christian activity. No other English diocese was ever so casual. But because it is such a likeable, even loveable city, as opposed to a merely impressive or handsome one, no one, except that sour and accurate nineteenth-century antiquary-historian, John Latimer, has liked to stress the disgraceful truths about its history. Bad judgements or cowardly indecisions have resulted in Bristol being built in the wrong place: a semi-defensible site easily commanded by artillery from the edges, a port barely accessible from the sea, though

ABOVE LEFT Totterdown's artisan edge and the New Cut, constructed in 1809 to act as a tidal bypass for the Floating Harbour.

ABOVE RIGHT Three edges, one of mud, one of linear restraint, one a heaving skyline – the Gorge, St Vincent's Parade and the wood below The Paragon and the Prince of Wales Crescent.

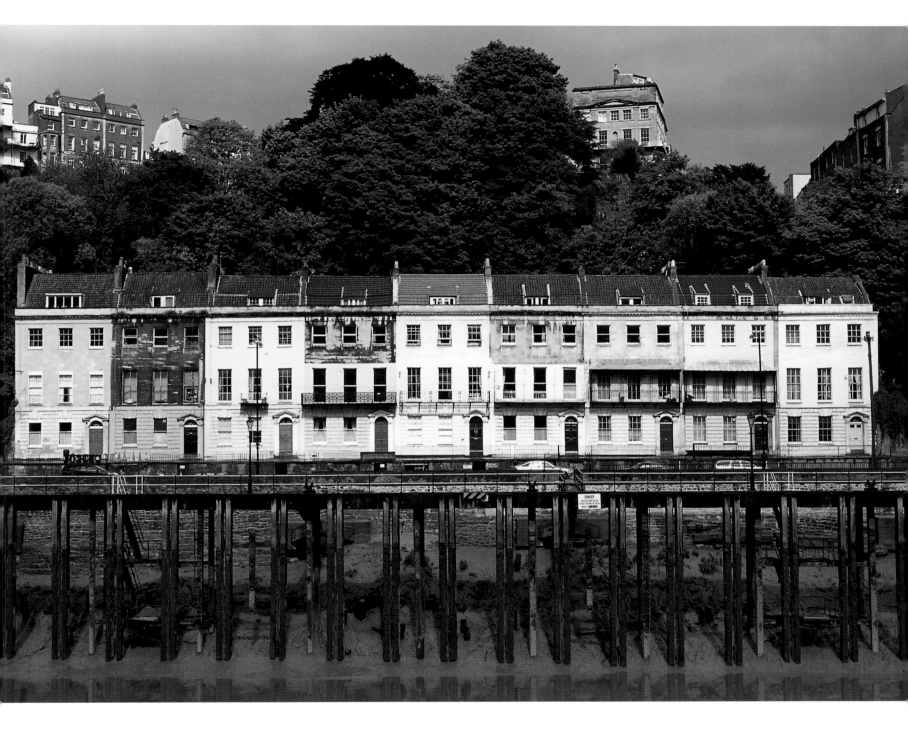

theatrically memorable behind its Avon Gorge and under its louring heights. From the football-pitch vacancies of the Downs in the north-west to the scabrously attractive relics of brass smelting around Arno's Vale at Brislington in the south-east and the grotesque Warmley Giant in the north-east, it never settles upon a convincing nucleus, not even of shopping centres. These open and then wilt away, at Clifton Down, Queen's Road, Park Street and Broadmead. Out at the sides, aristo-cratic Clifton Village and charmingly naff, artisan Bedminster run their successful rival shopping areas. Then in the grand old tradition of Bristol's inspired selfishness the twentieth-century city fathers have quite recently created a profoundly soulless new out-of-town shopping mall at Cribbs Causeway near the M4 and M5 motorway junction. To reach it every shopper must make a long car or bus journey, and it has no better purpose than to undercut Broadmead and the shops of the small towns and villages for fifteen miles around. There is, however, an intriguing kinship of lunacy between that planning decision and the fifteenth-century conspiracy by Bristol's merchants to keep a secret of their discovery, or possessive awareness, of the American landmass, so that they and the Portuguese could control the cod fishing on the Grand Banks. Meanwhile Columbus, deservedly, took the credit and the fame for discovering America.

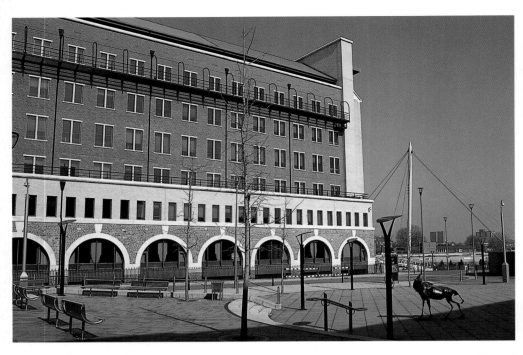

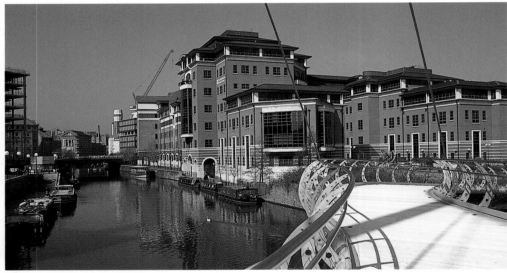

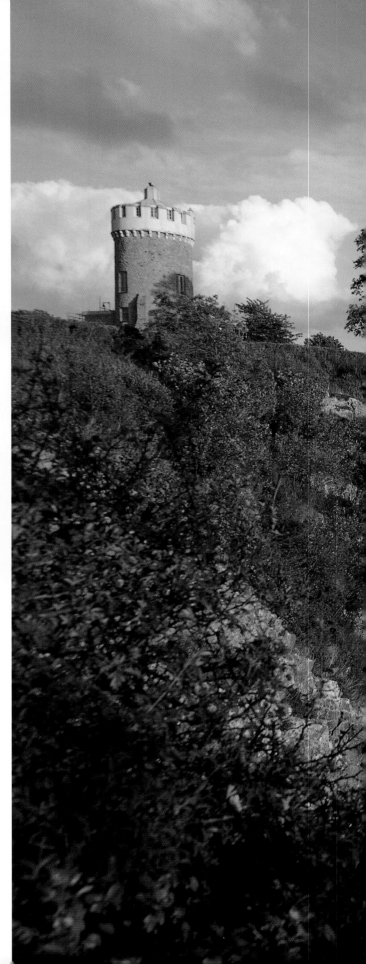

Yet with all this accumulation of folly, Bristol's architects, artists and maladroit merchants have created along its edges areas of seduction, of charm and often of national stylistic importance. These it will be the aim of this book to explore. Not, however, by way of Bristol's very own miniature motorway, the M32, which impels drivers headlong into the loutish Temple Way, a showcase of dull buildings leading to the city's latest venture, a business district at Temple Quay modelled upon the mistakes made by American cities of the mid-west in the 1930s. There is another more logical and far more historic way into Bristol; one which few ever take today, but which explains the city's chronology, growth and subsequent faltering with devastating visual clarity. This is the voyage up the Avon and through that Avon Gorge which has shaped the city's compromises, its visual riches and its insoluble, though always fascinating, problems of image and of planning.

TOP LEFT **In the late 1990s Bristol found inspiration for Temple Quay in the office blocks of the American Mid-West.**

ABOVE LEFT **Predictable Postmodern elevations on Avon Street are relieved by a curvaceously snaking footbridge designed by W.S. Atkins & Partners Overseas, 2000.**

RIGHT *Camera obscura,* **Giant's Cave and the epitome of Romantic engineering.**

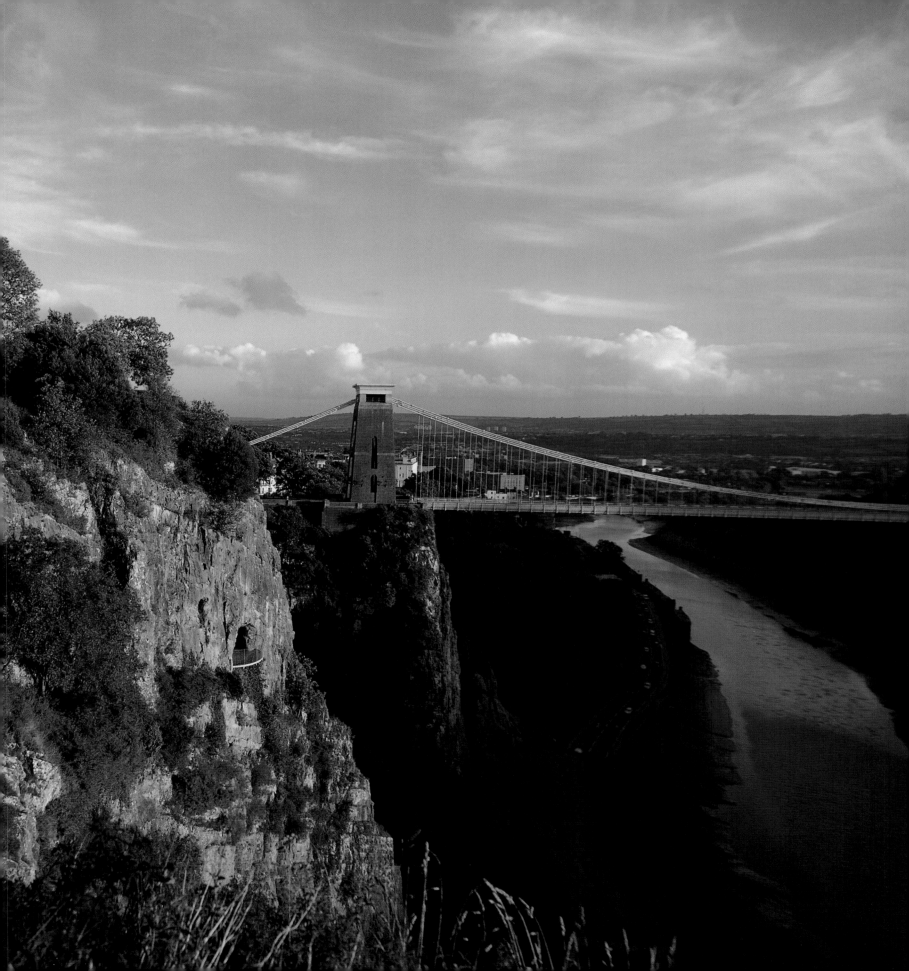

a port in strategic retreat from the sea

Avonmouth is the obvious place: where Bristol should have been built if the city had ever been seriously intending a maritime career, rather than the role of a market town with a bridge. This, therefore, is where a major modern port – Royal Portbury Dock – has eventually been allowed to grow up. But whereas Clifton and Bristol go together like horse and cart, no one thinks automatically of Bristol and Avonmouth. Accidentally, the city has, in this detachment, been environmentally clever. When, back in the eighteenth century, heavy industries, collieries, steel works, leather tanning and, worst of all, glass manufactories, were all based in the bowl of land where the Old City was built, the fumes and contamination were stifling. Visitors dismissed the place as a 'dirty great shop'. But now all that reeking area around Temple Meads railway station and Canons Marsh has gone idyllically derelict while Avonmouth has become a frightening concentration of the most hellish industrial plant: oil refineries, chemical works and the latest refinements in waste reduction, a place for mysterious explosions and fires. All these horrors grind away on open, level land where a city could quite easily have grown up, but the only connections today between Avonmouth and Bristol are the Portway along the Gorge and a frail Severn Beach rail link of Ealing Comedy unreliability.

Until a few years ago the port was run directly by the City Council, predictably at a loss, in a near permanent embarrassment of strikes and confrontations. Mercifully the Council accepted its incompetence and handed the docks and the dockers, over to private enterprise; since when Portbury has never looked back, but swung into profit with great container ships bringing in a shining host of foreign cars.

A little way up the Avon, that grossly tidal river runs through meadowland with virtually no hint of the proximity of a great city. These reaches are the celebrated Hung Rode and Kyng Rode, true markers to Bristol's dysfunctional siting. Even in the

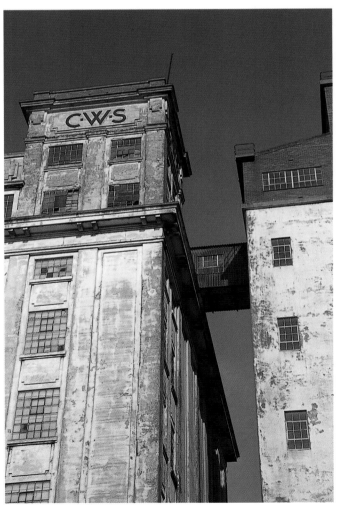

ABOVE **Distressed textures and the charm of decayed industry at Avonmouth.**

RIGHT The 1870s Gothic Revival interior of Brunel's Temple Meads station.

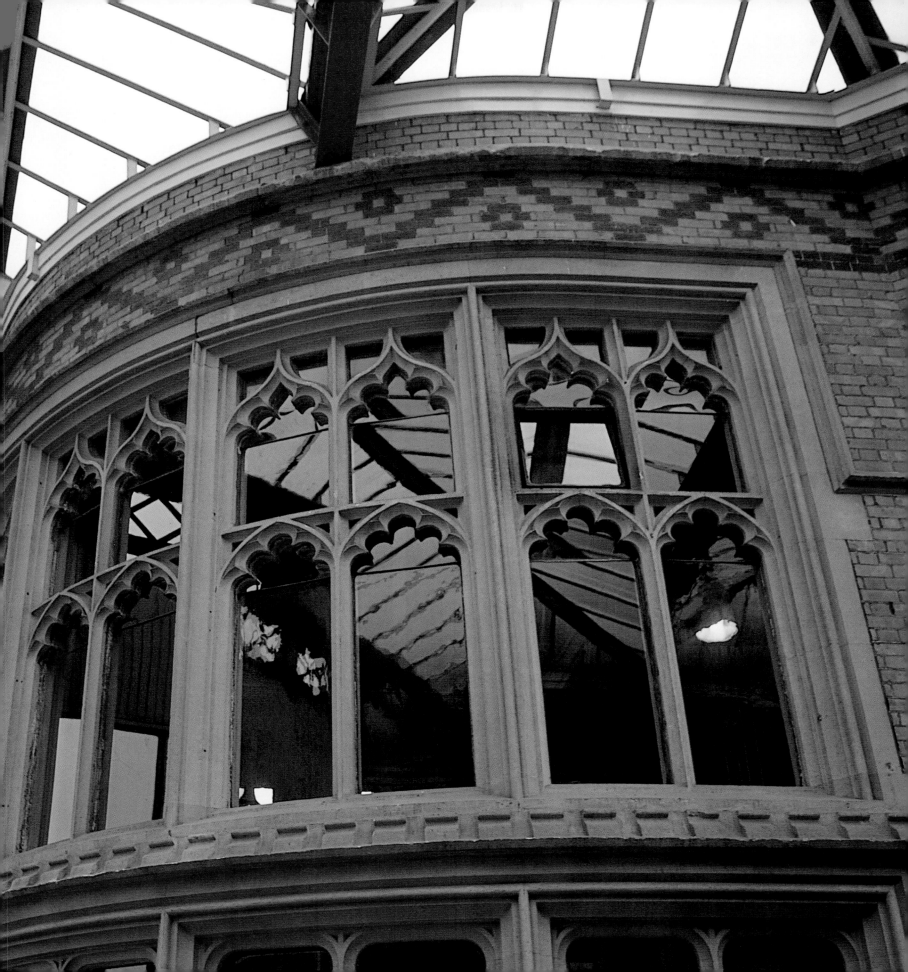

eighteenth century large boats were reluctant to risk a passage through the Gorge up into Bristol's break-back anchorages. Instead they would tie up here in the Rodes and disgorge their cargoes, at a price, into a shoal of barges. The little village on the Somerset shore, Pill, with its pilots, must have made a killing on handling the interchange. Then, after the Rodes, but still on level land, comes Sea Mills with the creek of the river Trym, a great place for blackberrying, though not much else. This was Abonae where the Romans would have sited Bristol, their port for ferries to Wales at the end of the Via Augusta; but it was never fated to become Trymchester. Somewhere around AD 850 an unknown and unchronicled group of Saxon sea captains and Saxon merchants, terrified by the prospect of Viking pillage and murder, must have taken the cowardly but understandable decision to build their trading settlement further up river, beyond the towering cliffs of the Gorge on a level site where the Frome, linking up with the Avon, would pro-vide unlimited moorings (although for half the twenty-four hours of the day their ships would rest on stinking mud). No Viking, they judged correctly, would risk his longship up a Gorge where one boulder, hurled accurately from 200 feet above, would spell ruin. For good or ill the Avon Gorge protected and created Bristol; and out of respect the city has had the grace to leave it wooded, precipitous and largely natural, with surprisingly few houses looking down into it. Rare shrubs and flowers grow in a romantic wilderness where, on most fine afternoons, rock climbers practise their skills, apparently dicing with death, but actually working up well-charted routes of cracks and crevices in the limestone.

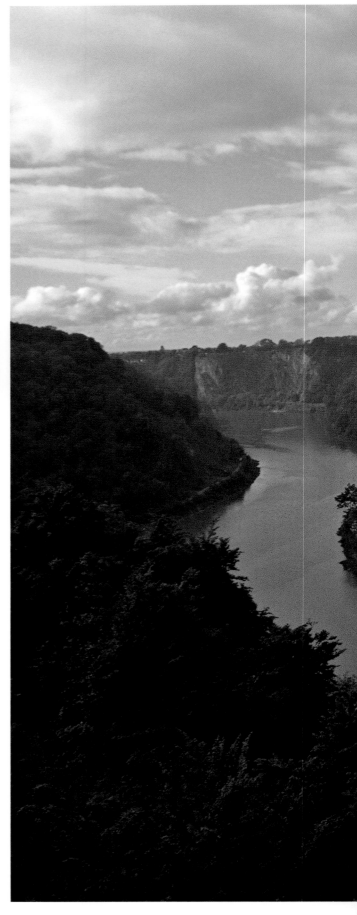

ABOVE The Severn Beach railway line crosses the Roman harbour at Sea Mills.

RIGHT Only the Portway slightly reduces the Savage Picturesque impact of the Gorge.

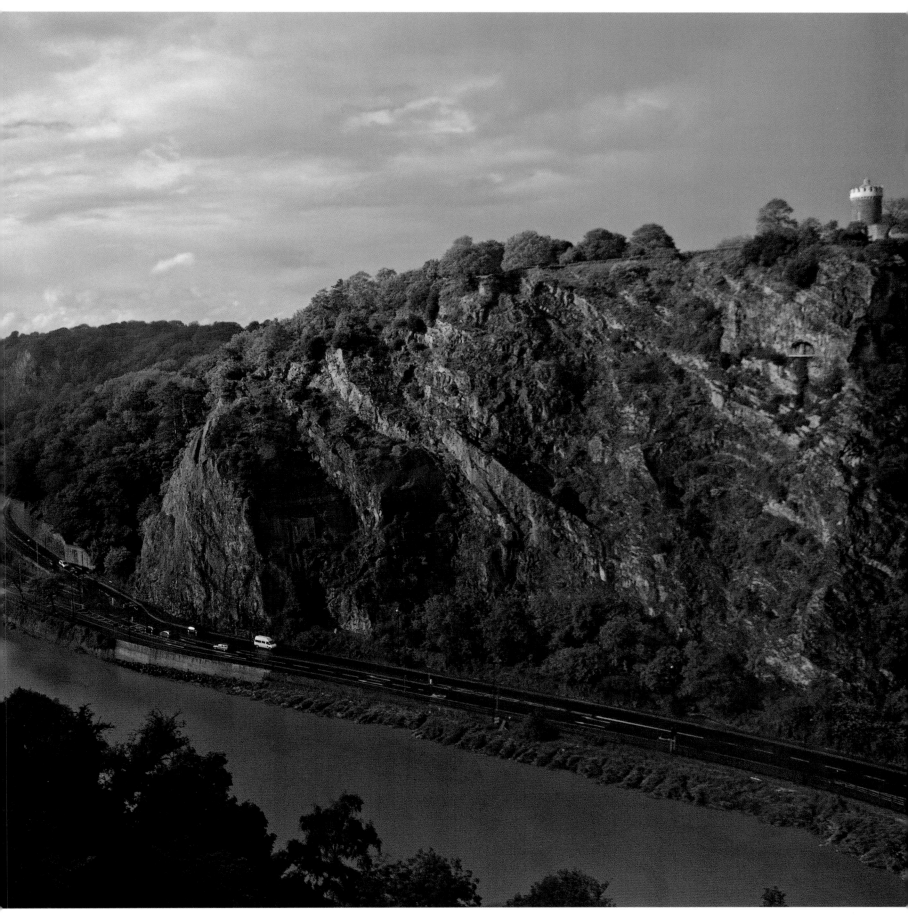

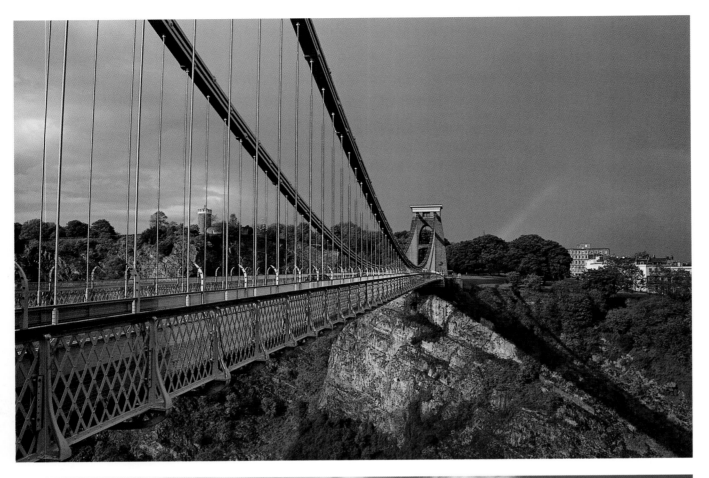

ABOVE The miracle of the Clifton Suspension Bridge. Brunel was only twenty-three when he designed it in 1829.

LEFT Bristol's ultimate edge. Brunel wrote that 'a work of art thus thrown across such grand and imposing scenery should be as simple as possible.'

RIGHT The Gorge at full tide and in full flower.

FAR RIGHT Decaying jetties near the original Hot Wells Spring

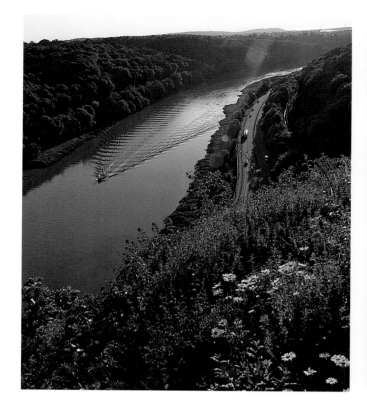

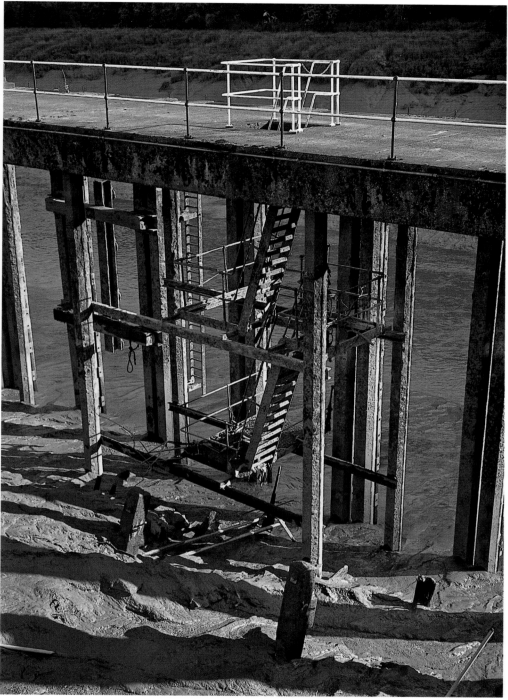

It is just before the rhythm of Clifton's natural topographical edges and artificial terraced ledges comes curving in on the left-hand skyline that Bristol's ultimate and engineered edge, the Clifton Suspension Bridge, cuts overhead in pure, breathtaking geometry. At great expense, and rather to vault the gulf as a technical dare than to solve a transport problem, it was built to Isambard Kingdom Brunel's design between 1831 and 1864. The city required it to gratify its romantic appetite for heights, edges and engineering solutions. Now it is second only to Beachy Head as the suicides' gateway into the next world.

After the Suspension Bridge, Clifton becomes visually stunning, a suburb almost as suspended as its bridge. Windsor Terrace was begun in 1790, to a design by the Bath architect John Eveleigh, who should have had more sense than to entrust an ambitious Bath design to an incompetent Bristol builder. The bankruptcy of the speculator, William Watts, inventor of the shot tower process for producing lead shot, interrupted its construction with only the centrepiece finished. When work resumed in 1808, under John Drew, the pilasters on site were reused and, due to the reduction in the height of the houses, failed to reach the cornice they were supposed to support. The promenade façade may be botched, but its rear elevation is Wagnerian, poised directly over a near 200-foot drop of sheer red rock, carved out with several storeys of its cellars. Beyond it the terraced edges unfold in one concave or convex after another of classical housing, each wrapped stylishly around wooded cliffs: Prince's Buildings, The Paragon, Cornwallis Crescent and, largest of all, Royal York Crescent, rippling out the light patterns of its fenestration above a massive substructure. Hidden away, almost unnoticed at the foot of the cliffs is the tiny Colonnade of 1786. This is all that survives of the city's once famous Hotwells Spa, the social nexus from which Clifton grew. Lukewarm saline water seeped out inconveniently from rocks below the high tide level so, on an awkward peninsula of land that boats had to steer around, a Pump Room was built to contain the supposedly healing flow and a Long Room raised for concerts and public breakfasts. Both the peninsula and the spa complex went long ago, but the Hotwells suburb remains one of Bristol's earliest orderly enchantments, with two major claims upon the city's gratitude.

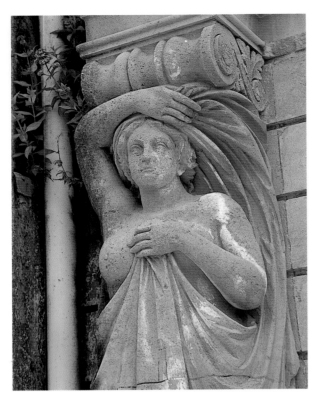

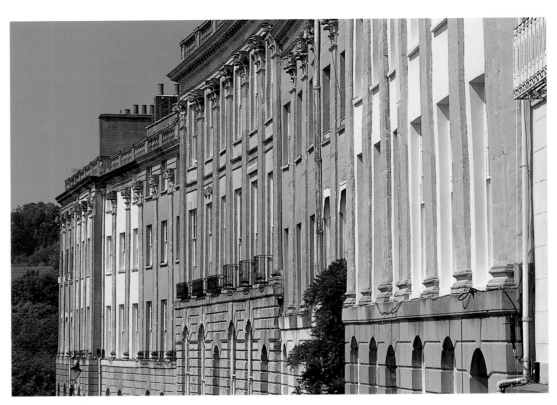

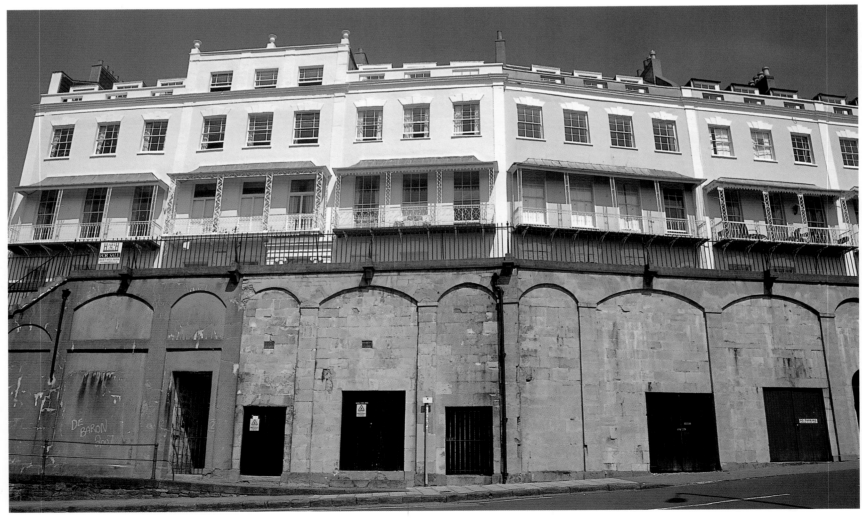

FAR LEFT Modest caryatids support the façade of the former Grand Spa Pump Room below the Avon Gorge Hotel, designed by Philip Munro in 1890–94 to revive Clifton as a spa.

LEFT The disjointed charm of Windsor Terrace, first projected by the speculator William Watts, inventor of a new process for producing lead shot.

BELOW LEFT Elegance poised above crudity – Royal York Crescent (1791–1820) on the arcaded substructure which supports a promenading terrace giving panoramic views over the Avon.

BELOW Where invention fails, sheer repetition succeeds – Bristol's finest double-decker grandstand, at Royal York Crescent.

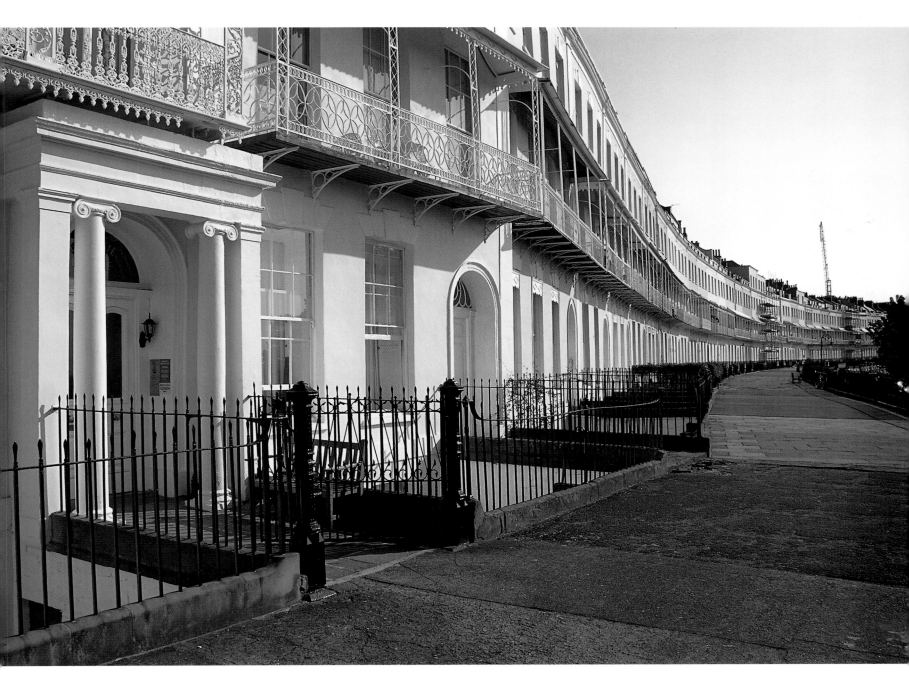

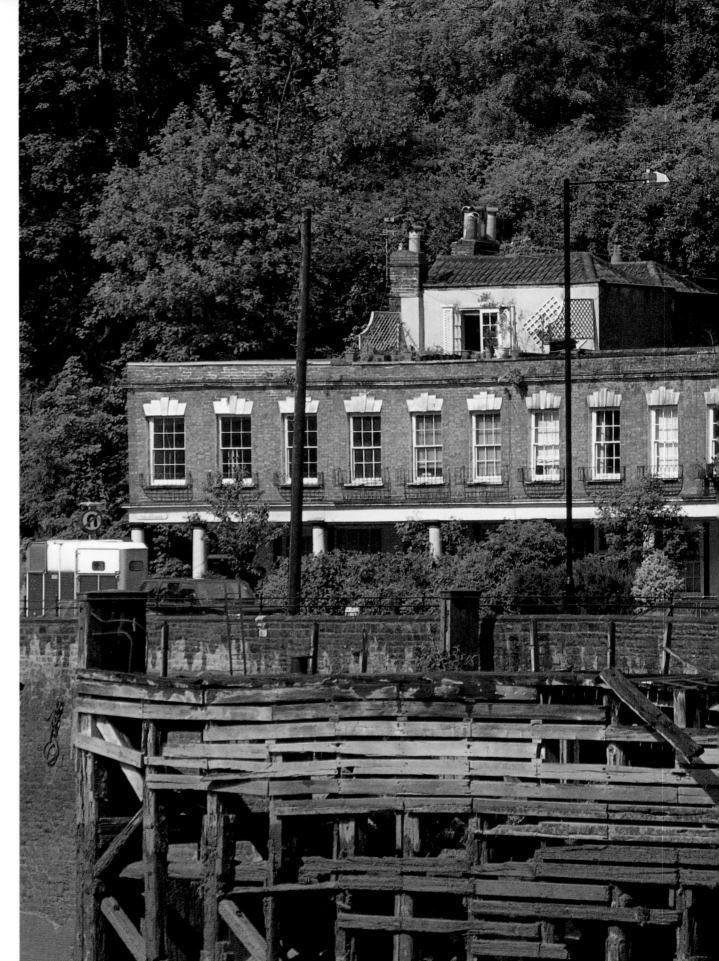

The Colonnade of 1786, which
originally housed shops, and
the 1740s Rock House – all that
survives of the Hot Wells Spa.

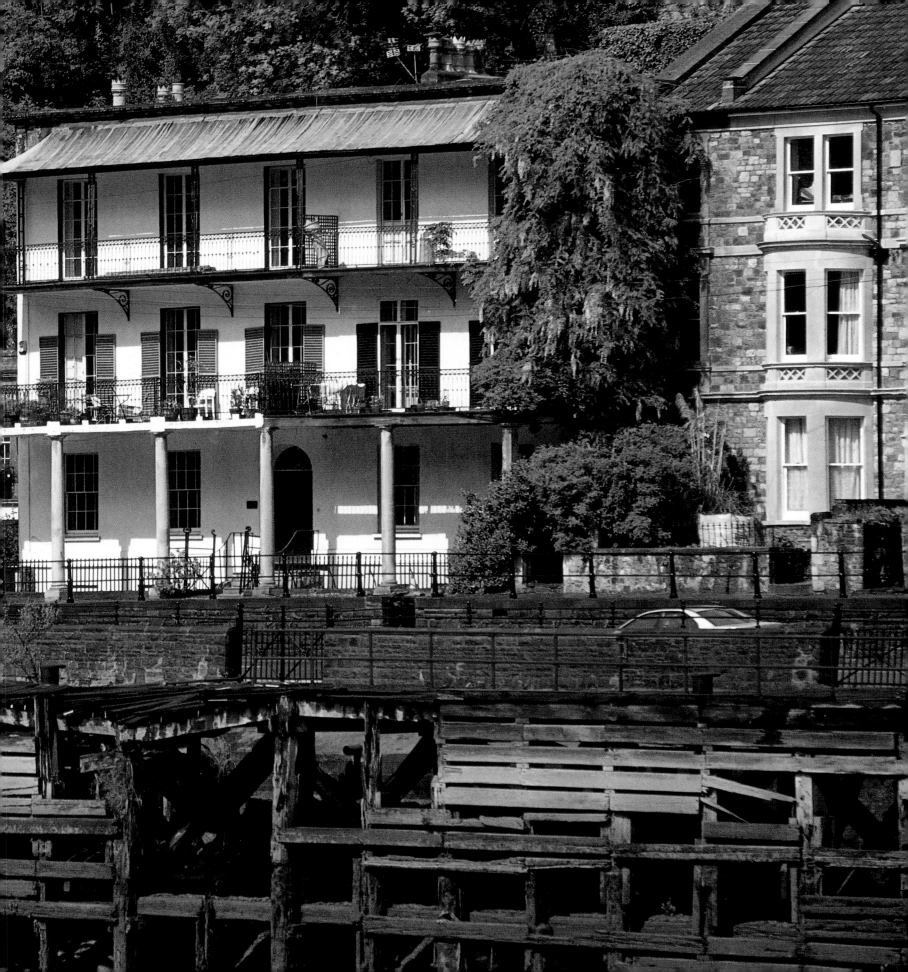

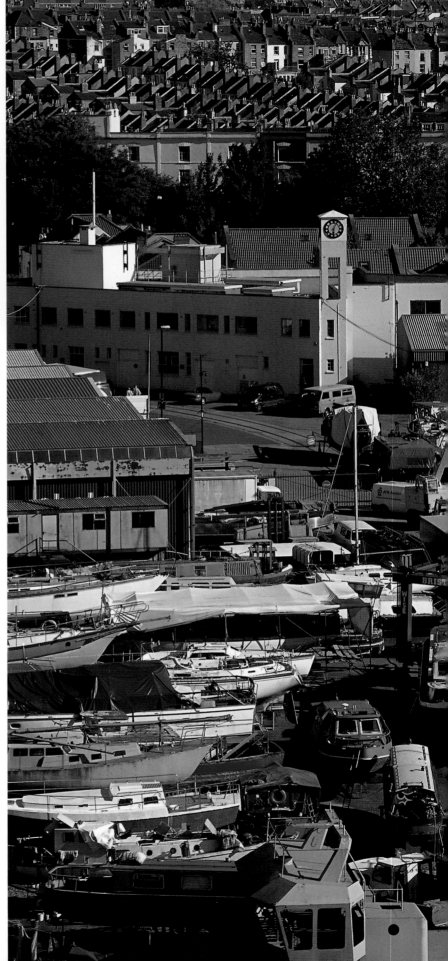

The first is that it was upon the heights above its trim, brick houses of Dowry Square and Dowry Parade, constructed to a subdued Quakerish design between 1721 and 1762, that the Society of Merchant Venturers absorbed the notion that more impressive terraces, first in brick at Albemarle Row of 1762, then in stone, could be constructed to raise the land value of the Society's extensive holdings in the Manor of Clifton. Mistakes would be made with fudged palatial designs like Windsor Terrace, and the 1793 economic collapse would linger out some building programmes; but it is only necessary to look up from the tame brick elevations of George Tully's Dowry Square to the triumphant heraldic silhouette of The Paragon, built by John Drew and Stephen Hunter between 1809 and 1814, to perceive the leap into imaginative design evoked by the challenging environment of the Hotwells. The Paragon is one of England's great buildings. It makes Regency classicism grow out of nature as flexibly and satisfyingly as any of Frank Lloyd Wright's houses. With its concave entrance front and convex garden elevation it positively dances along the precipice, playing variants of balcony, sash window, porch, basement and fanlight. Architecture can sometimes sing.

The Hotwells' second claim on Bristol's gratitude is the Black Gates. In 1804, after much hesitation and a delay that allowed Liverpool to take a permanent lead over Bristol as the Atlantic port, the city finally accepted William Jessop's complex plan. Engineers began the huge lock gates that would create the Floating Harbour and remove Bristol from the tyranny of a fifty-foot tidal fall and the subsequent stinking mud. While the cliff edge terraces produced Clifton, the Floating Harbour saved the Old City's maritime image and made it eternally picturesque. If the lock gates, wide enough to take Brunel's Great Western and his 3,720-ton Great Britain, were both opened together, and provided it was low tide, the Old City of Bristol would be reduced, within minutes, to a visual slum.

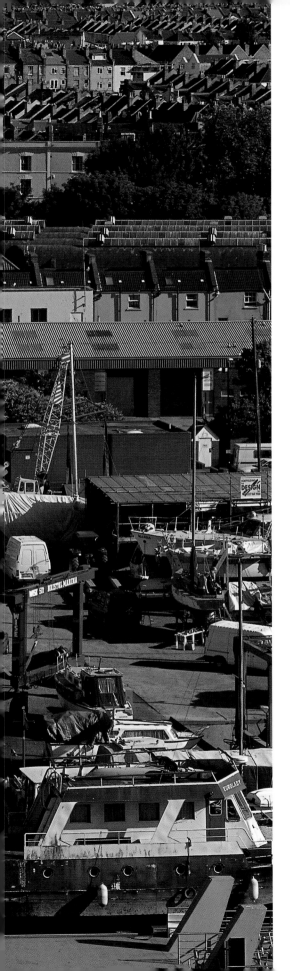

FAR LEFT **William Jessop's Black Gates hold up the Floating Harbour, constructed between 1804 and 1809.**

LEFT **Chandlers' yards and weekend sailors create the illusion of a still-active port.**

RIGHT **John Drew's Paragon of 1809–14, Clifton's boldest terrace, is concave on its entrance front and convex at the back, to take in the views.**

All the reflecting, flattering mirrors of its broad quays and inlets would be turned to dreary rubbish-spattered mud flats, and its thousand small boats would lie forlornly on their sides.

The truth is that while Bristol was, in the days of small ships, an historic port, it is now an inland city, protected from the Severn estuary by wooded hills. To cling on to that vital image of a one-time great port it desperately needs those glimpses from its streets of wide waters, apparently busy quaysides and many masts. Then there is that photogenic intensity of form, which the artist John Piper noted and admired, that seems to gather around the trappings and machinery of a maritime site: bollards, anchors, chains, cranes and all those prows and top-gear are strengthened and streamlined to cope with the pressures of storm. Because of Jessop's Black Gates, Bristol still looks and even feels like a port. This may be an illusion, but the visual drama is real.

the floating harbour

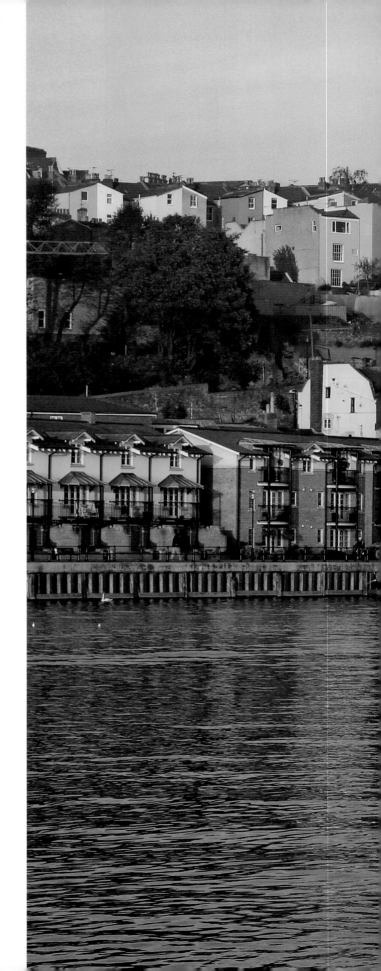

Lying so close up against the demure brick houses of the Hotwells and the sweetly named Rose of Denmark pub, Jessop's lock is grim, deep and dangerous. But, immediately the wide Cumberland Basin opens up beyond it, the flattery of light and water begins, with the north side of the Harbour scoring heavily, time and again, in the colour and form of its edges, compared with the lacklustre parade along its southern banks and quays. Between them the two sides of the Floating Harbour present a cruelly accurate critique of what works and what does not work in historic and modern architecture around a changing city. The lesson, above all else, is that variety of scale is essential. Big buildings desperately need small buildings, humanly scaled, close alongside, to bind them in and dramatize them.

At first there are no problems. On the north bank the 1999 housing on Poole's Wharf, by Philip Thorpe for Crest Homes, is marvellously modest in scale and, apart from one gloomy range in dark, sullen brick, is alive with colour-washed rendered surfaces, balconies, flowers and flourishing front gardens. What is so effective is the retention at the quayside borders of terraced forms even for these two-storey houses. Up behind them on the steep wooded slopes of Cliftonwood, a line of delicately frail late-Regency cottages, twenty of them, every one painted a different seaside colour but with blue prevailing, runs through the trees, a most Cliftonian *rus in urbe*. Green and precipitous back gardens are a city speciality.

On the south side, Brunel's ingenious pump for cleaning the Floating Harbour's inevitable filth pulsates away in the retiring angularities of Underfall Yard. Then comes the disastrous Baltic Wharf, a housing development of 1986, by Halliday Meecham Partnership, that ignores the long Bristol tradition of terraced edges, choosing instead heavy, gabled semi-detached apartment blocks of brick; their ironwork, timbering and window framing all in the same unrelieved brackish colours. Brown

RIGHT **Evening light on the colour-washed modern townhouses of Poole's Wharf, with similar late Regency cottages above.**

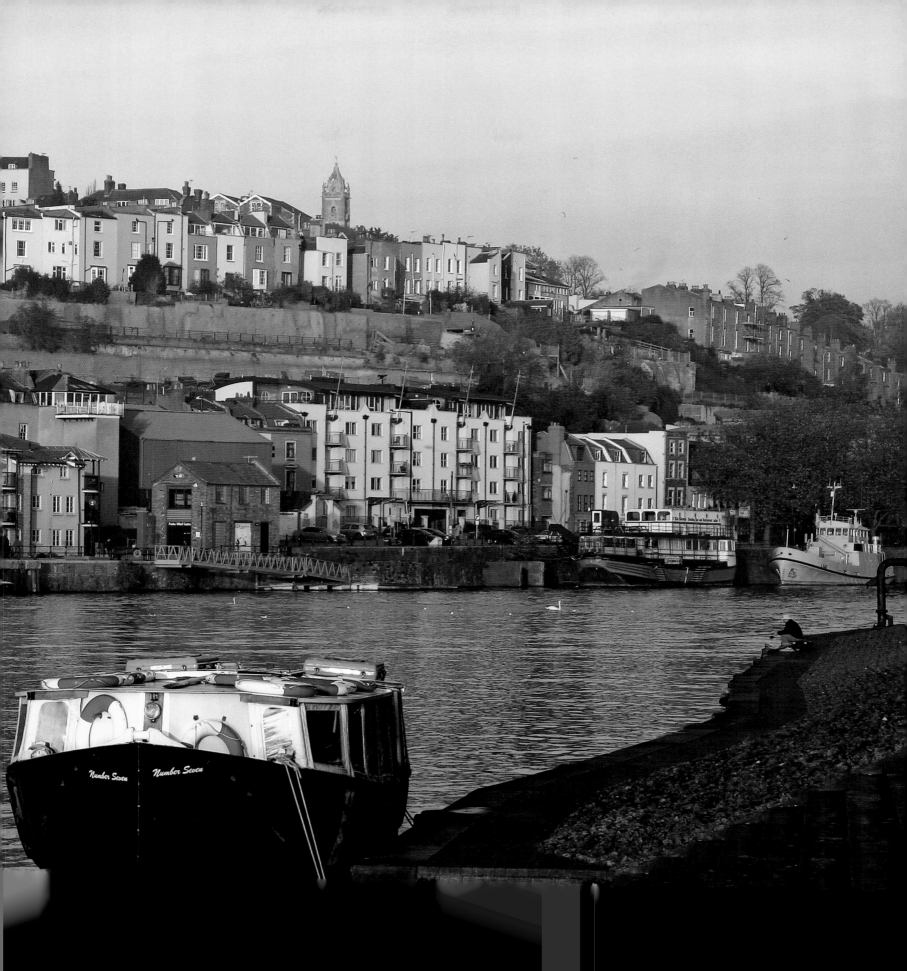

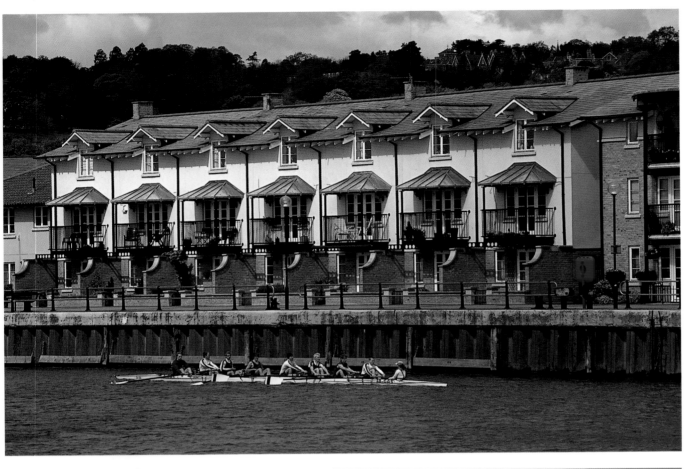

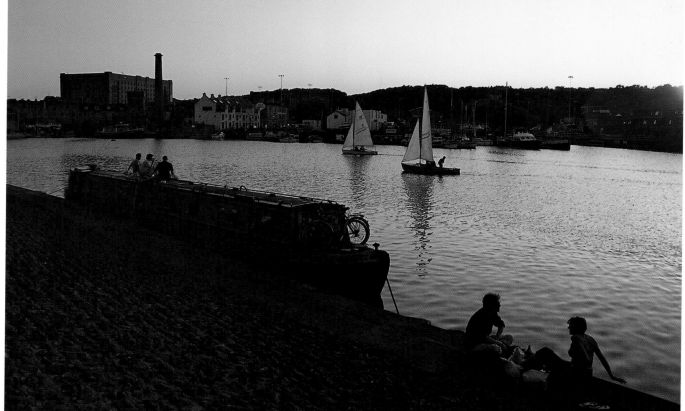

ABOVE LEFT A modern version
of traditional Bristol terraced
housing works well in Philip
Thorpe's 1999 Poole's Wharf.

LEFT Modern Poole's Wharf
and the 1850s houses of
Cliftonwood up the hill.

ABOVE RIGHT The natural
horizontality of Clifton, at
Cliftonwood.

RIGHT With the advantages
of water and reflected light
urban poetry comes easily –
the Floating Harbour looking
towards Underfall Yard.

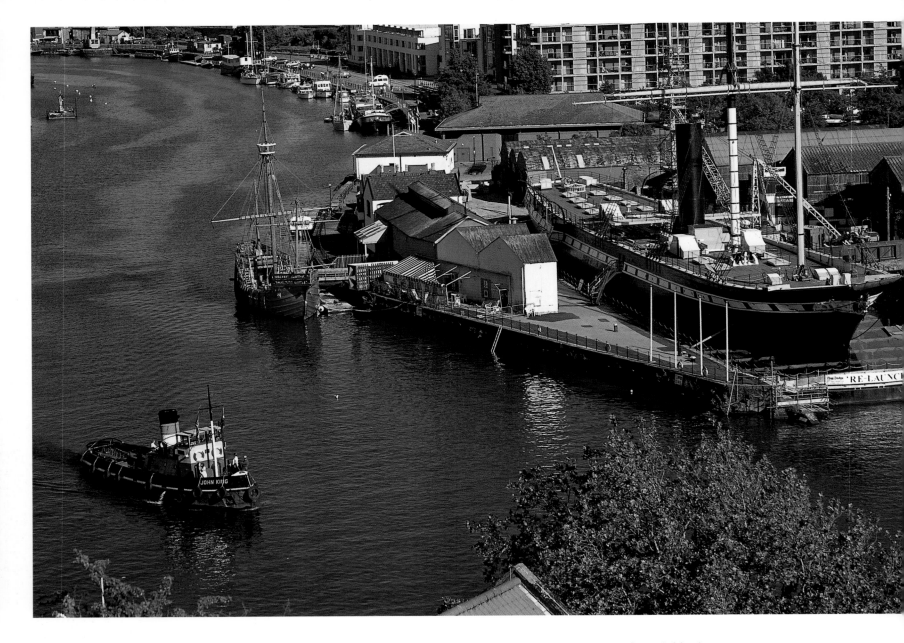

brick does not reflect light even though a waterside is full of light. The impact of these blocks is staid, suburban and entirely un-maritime, while the monolithic former Wills tobacco Bonded Warehouses of 1903 in the background only depress the composition further.

Across the water on the north bank, facing the formidable competition of a graveyard of dead ships and the *Great Britain* herself, alive with flags, dwarfing the replica of John Cabot's *Matthew* moored alongside, is Capricorn Quay of 1998 by the Alec French Partnership. These apartments are a most telling example of brilliant form and bad colour. The blocks writhe and twist out of the waterside with an almost baroque movement of vital form rising to upswept roofs. They should be perfect for their strategic site, but their colour is disastrously underplayed in Bristol good taste, with uniform aquamarine metal balcony screens against dull grey walls. A clash of primary colours and black detailing would rescue them.

It is perhaps premature to be gloomy about Canon's Marsh, the next and most commanding area of the north bank, but in 2005 it looks likely that the errors of dim colour and lack of contrast in scale are going to be made there again. No modern Bristol architect seems to have noticed that Bristol was originally a polychromatic city of Pennant stone from the multicoloured quarries lining the Downs. Canon's Marsh was undoubtedly a challenge: a whole peninsula of derelict industry lying directly underneath Bristol Cathedral's most attractive south elevation and neighbouring the Old City across St Augustine's Reach. Perhaps the iconic value of the site has made both planners and architects nervous, in a way that Philip Thorpe was not nervous or over-stressed when he designed the charmingly homely crescents around Poole's Wharf. Or perhaps it was just the sheer financial value of an acre on the Marsh that seemed to demand impressive campus-style projects; but that is what has gone up.

ABOVE The replica of John Cabot's *Matthew*, berthed beside Brunel's *SS Great Britain*.

RIGHT Alec French Partnership's late-1990s Capricorn Quay responds energetically to its Limekiln Dock site opposite the *Great Britain*.

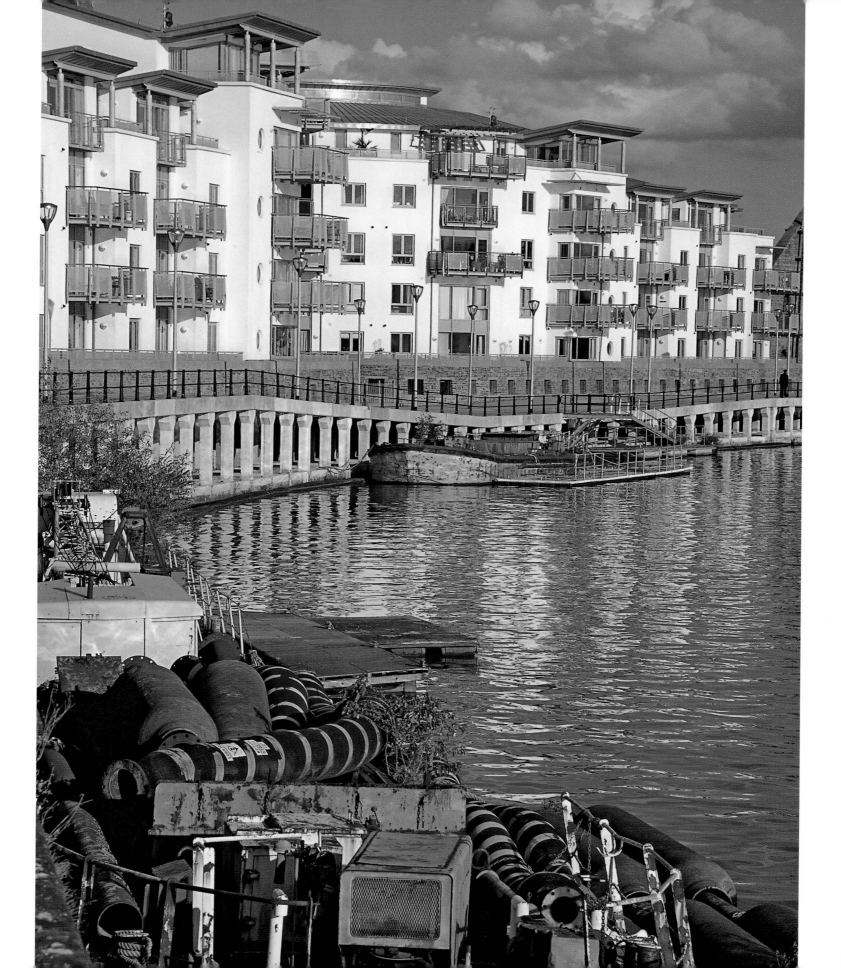

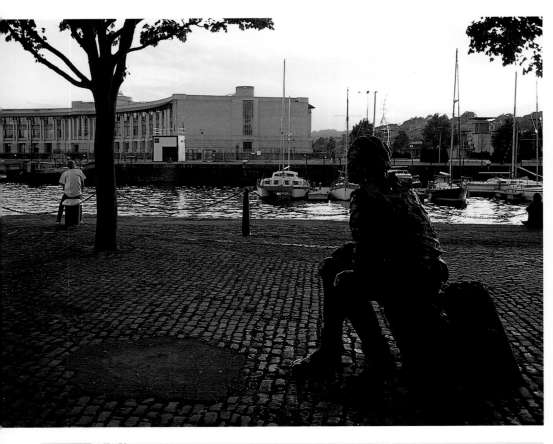

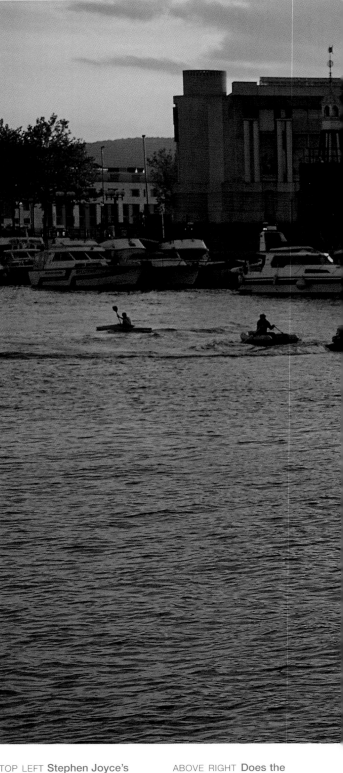

TOP LEFT Stephen Joyce's *John Cabot* sits brooding unpretentiously on the cobbles by the Arnolfini.

ABOVE LEFT The Floating Harbour, while not busy with commercial traffic, is still alive with ferries and pleasure boats.

ABOVE RIGHT Does the bombastic Postmodernism of the Lloyds TSB building provide the right solution for its harbourside site?

First came a true crescent for the water's edge: the Lloyds TSB headquarters by Arup Associates of 1988, in nervous Postmodern styling with a rotunda behind it in much the same tentative traditionalism. The crescent faces a pointless, empty piazza and the rotunda seems to sit in a sea of parked cars. If only the piazza and the car park could be in-filled with small streets and alleyways of complex and coloured houses, like those on Merchant's Landing and Trim Mills beside the Bathurst Basin, Canon's Marsh would become part of the city's social fabric. As it stands, Millennium Square is a mere monument, given significance by giant ventilation shafts to an underground car park, a planetarium sphere of mirrors and William Pye's exquisitely tasteful Aquarena fountains. There are no houses, no shops, only gawping visitors and self-conscious attractions like Wildwalk, Explore and an Imax cinema, that may or may not be functioning in ten years time.

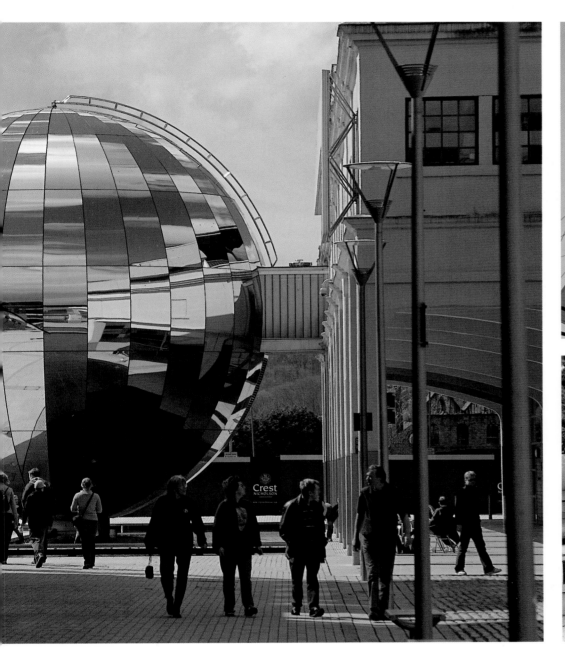

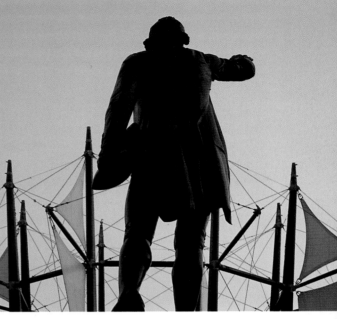

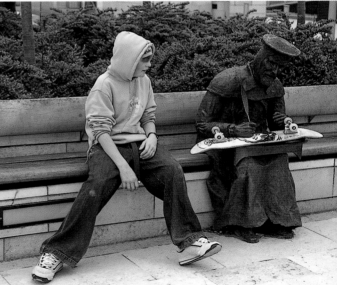

LEFT Alec French's ventilation shafts for the underground car park beneath Millennium Square are flattered by reflections.

ABOVE The visual drama of the mirror-finished Planetarium triumphs over functional utility in Millennium Square.

ABOVE RIGHT A city logo of masts and sails and James Harvard Thomas's 1894 statue of Edmund Burke, in The Centre.

RIGHT Whimsicality not bombast, in the modern mode – skateboarder and William Tyndale.

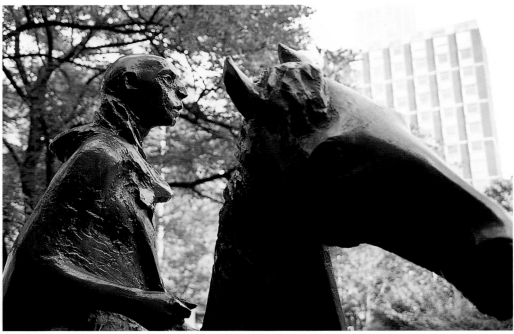

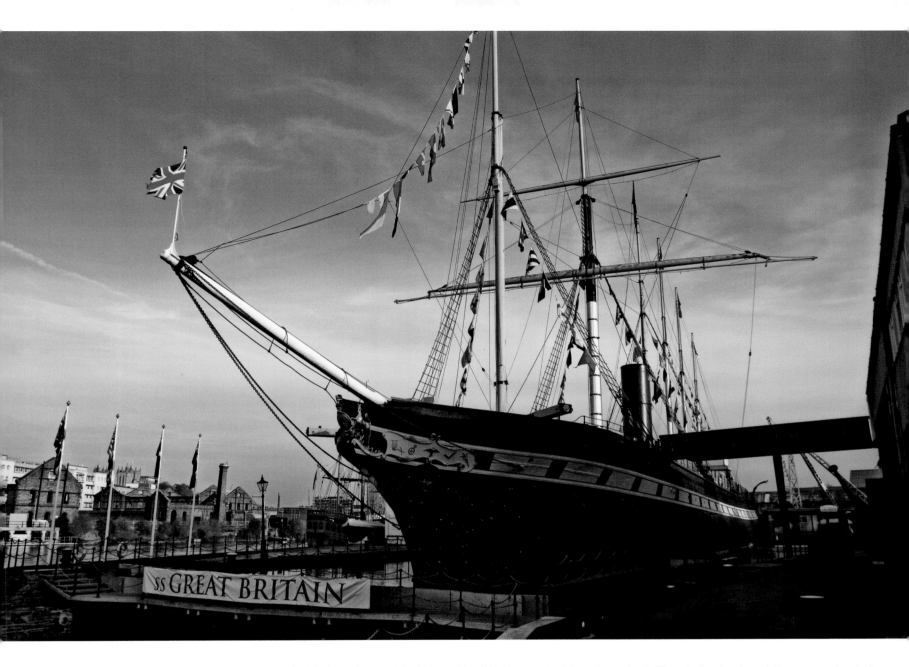

ABOVE With the *SS Great Britain*, rescued from decay in the Falklands in 1970, the city strives to reinvent itself.

OPPOSITE, CLOCKWISE FROM TOP LEFT Burke orates to an imaginary House of Commons; David Backhouse's 1984 emaciated sculpture of St Bartholmew astride his horse, at Lewins Mead; John Cassidy's 1895 statue of a thoughful Edward Colston; Is John Doubleday's 1982 statue of Brunel a sincere tribute, or a mockery of his height?

Further along the Harbour, beyond the Prince Street Bridge where there was not the same pressure to make bold civic gestures, the harbour sides work delightfully, with the *Thekla*, an ex-sand dredger, permanently moored by the Riverstation, a deft 1998 restaurant conversion by Inscape architects of the old harbour police station. When the half-modern, half conventionally eighteenth-century-style houses of the Ronald Toone Partnership's Merchant's Landing went up in 1980–84, critics tended to deprecate their safe conservatism, but their various bay windows and gently differing details have a human scale. That area opposite the Ostrich Inn is clearly happily populated. The water of the Bathurst Basin is alive despite William Bruce Gingell's grim General Hospital of 1853–7. There are coloured kayaks and those status symbol white boats: *Scottish Maid*, *Double Duo*, *Virago* and *Down in One*. They are probably moored for all but an hour or two each week, but

that is unimportant. They bob about and they are animated hulks for people to picnic and potter in. The spire of St Mary Redcliffe pulls the complex vistas and diverse details together and that most prominent and pastel-coloured of all Bristol's edge terraces, Redcliffe Parade of the late 1760s, presides serenely on its low red cliff. The textures here, particularly around the Ostrich next to its blocked railway tunnel, are a pleasure, with cobbles, rough rock faces, robust iron bridges, steps and the animation of eating and drinking out in the sun. No exact area of the Floating Harbour can be bracketed as conventionally picturesque, but it is uniformly interesting, always various, teeming with boats large and small that can never find it easy to make much of a voyage on these limited waters, but that assert or bluff their way into a bogus port identity without a breath of salt wind to support them.

RIGHT **On Redcliffe Backs the dockside verticals of the warehouses and new apartments work better than the Brutalist horizontals of the Phoenix Assurance block of 1974.**

BELOW **Evening light on the** *Great Britain*.

BOTTOM **Morning light on the** *Thekla*, **one-time sand dredger and later heavy metal venue.**

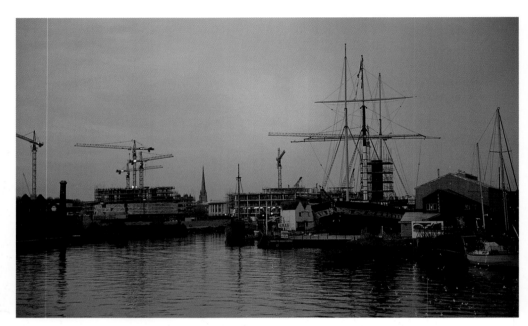

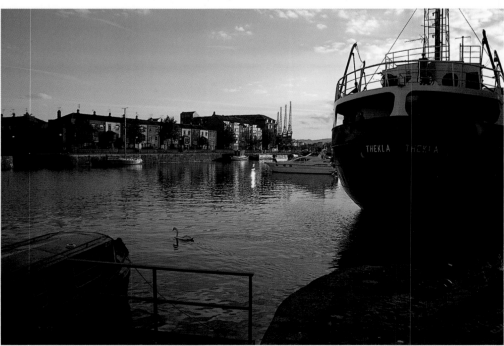

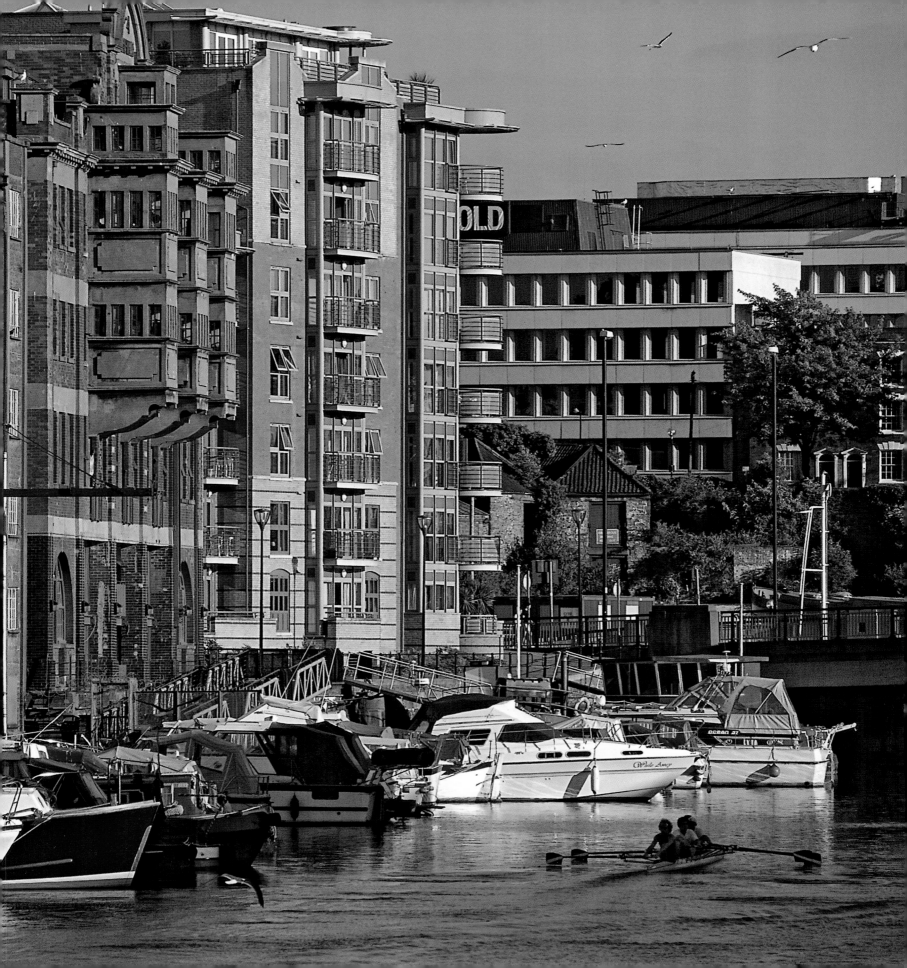

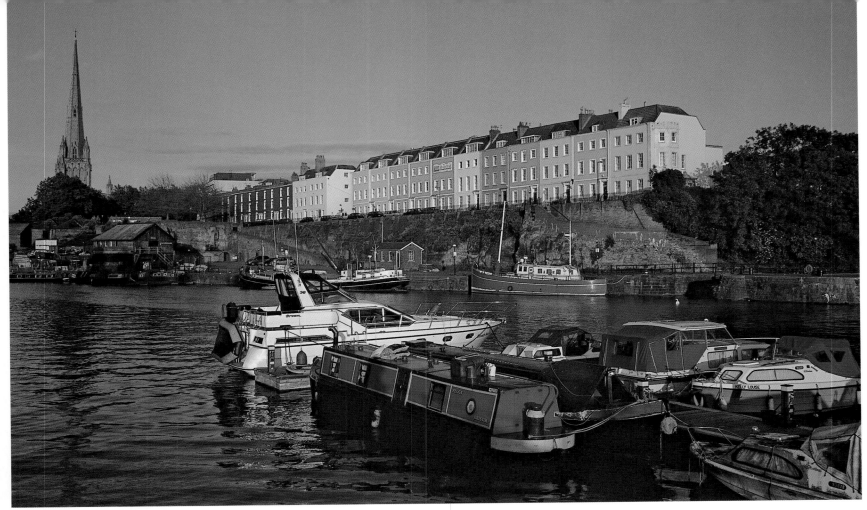
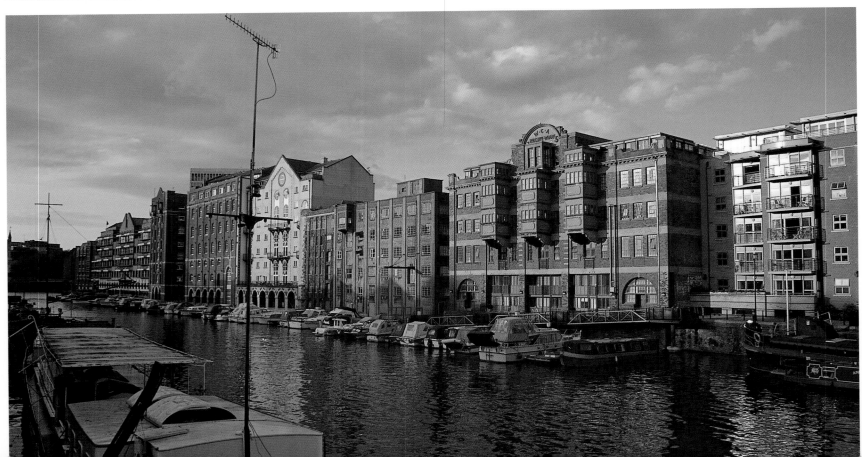

ABOVE LEFT On Redcliffe Parade the spire of St Mary Redcliffe church soars above the horizontals of seashore and roof tops.

BELOW LEFT W.H. Brown's WCA warehouse of 1909 is flanked by the slickly metalled and balconied Custom House apartments, by the Architecture and Planning Group, 2001.

ABOVE RIGHT Functional weights form an abstract sculpture on Pero's Bridge.

BELOW RIGHT Welsh Back serves as a flight path for swans.

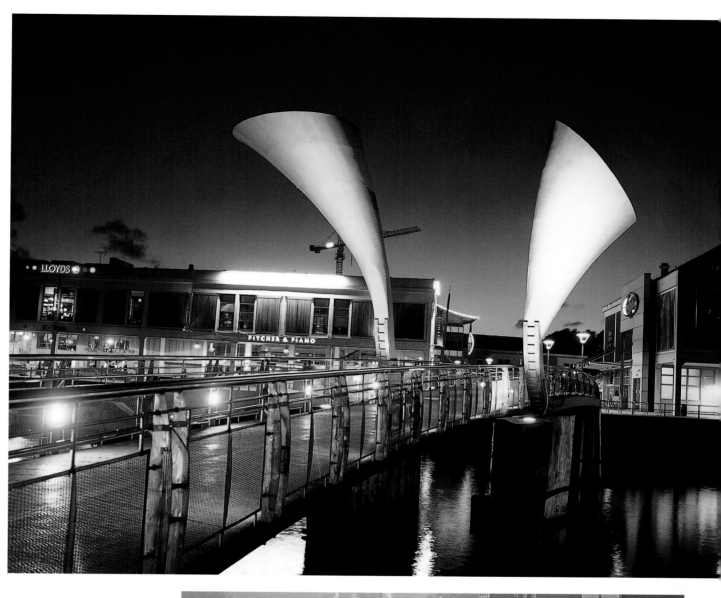

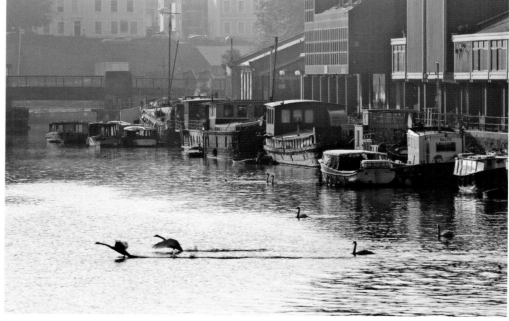

All of which suggests that public opinion was right and the Council's decision to keep the waters of St Augustine's Reach buried under the concrete of the Tramway Centre was wrong. What the city needed in this, its heartland, was the lap of waters, and a forest of masts, but the course of the river Frome remains culverted under a complicated traffic roundabout; the trams went long ago. It did seem, when Eilis O'Connell's Pero's Bridge (named after a slave brought to Bristol in 1783), was thrown across the Reach with its theatrical horned weights in 1999, that the Harbour might regain its original extension up to the very feet of the 1914–18 War Memorial on the Centre. Unfortunately more precious counsels prevailed and a modish, abstract composition of beacons and spurting fountains took the place of the municipal flowerbeds that had run down the spine of the Centre.

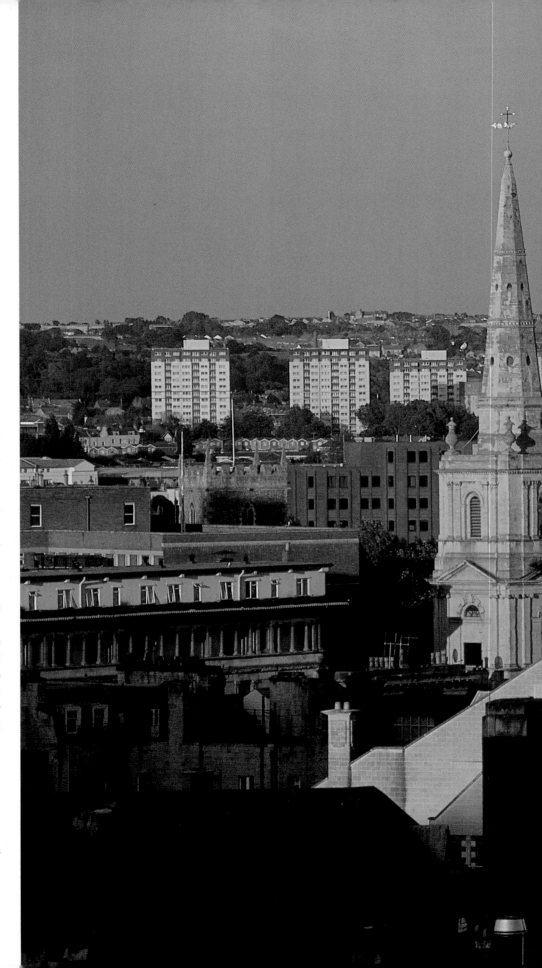

the old city

There was an enormous Bristol Castle, built by the Norman Bishop Geoffrey of Coutances before the 1080s, nineteen medieval parish churches, a whole chain of Friar's churches, massive Pennant town walls with fortified gates and row upon row of elaborately timbered houses overhanging their narrow roads. But time has never been over-kind to Bristol, and while fragments of these remain, none of them seem accurately to define the city's real riches. The German air raids of 1941–42 did irreparable damage, creating ruin around the Castle area so profound that the city planners threw up their hands in despair. In the early 1950s, when British architecture was at a nadir of cheap, dull simplicity, they abandoned the old bombed shopping centre around Castle Street which originally connected with Old Market, turned it into a charmless park set with two ruined churches, and contrived a new commercial centre on the Broad Mead. Worse still, in 1959 the Bristol Architects' Forum plotted a ridiculous new Bristol of two layers, one for the traffic on the ground and the other, for pedestrians, confined to aerial concrete ways suspended twenty feet high over the Centre to create what their report archly called a 'Venetian Piazza'. They even began to build this brave impossibility and fangs of it can still be followed over Rupert Street and Lewins Mead.

RIGHT The Georgian towers of Christ Church and All Saints grace the roofscape around Corn Street, while in the background the Dove Street flats are loutish monuments to the City Architect's Department.

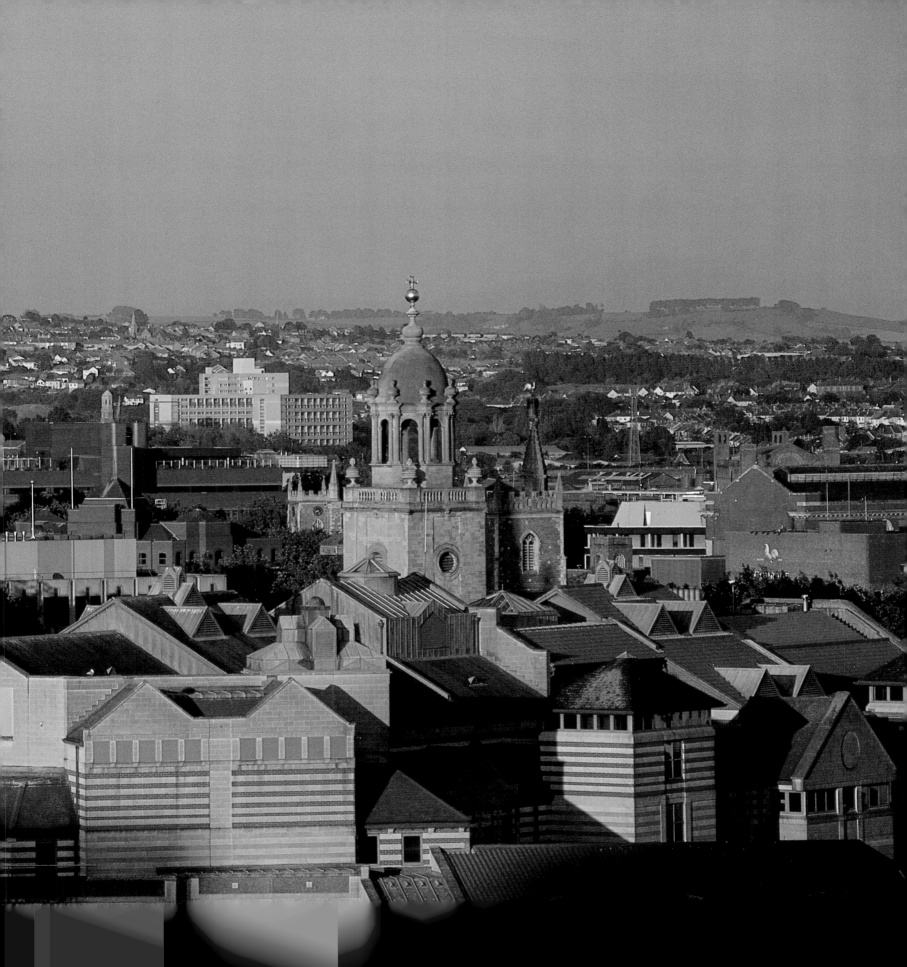

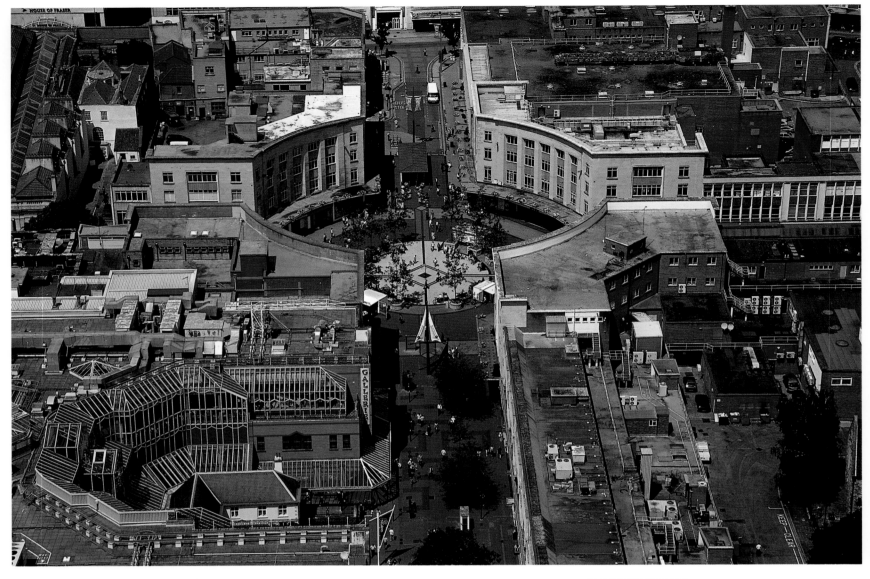

ABOVE Postwar planning at Broadmead offered nothing remotely redolent of Bristol's maritime and merchant past.

LEFT The preserved ruins of St Peter's church in Castle Park.

RIGHT A walkway in the sky connects the Old Market with Castle Park – a remnant of the absurd plan to create a two-layer Bristol.

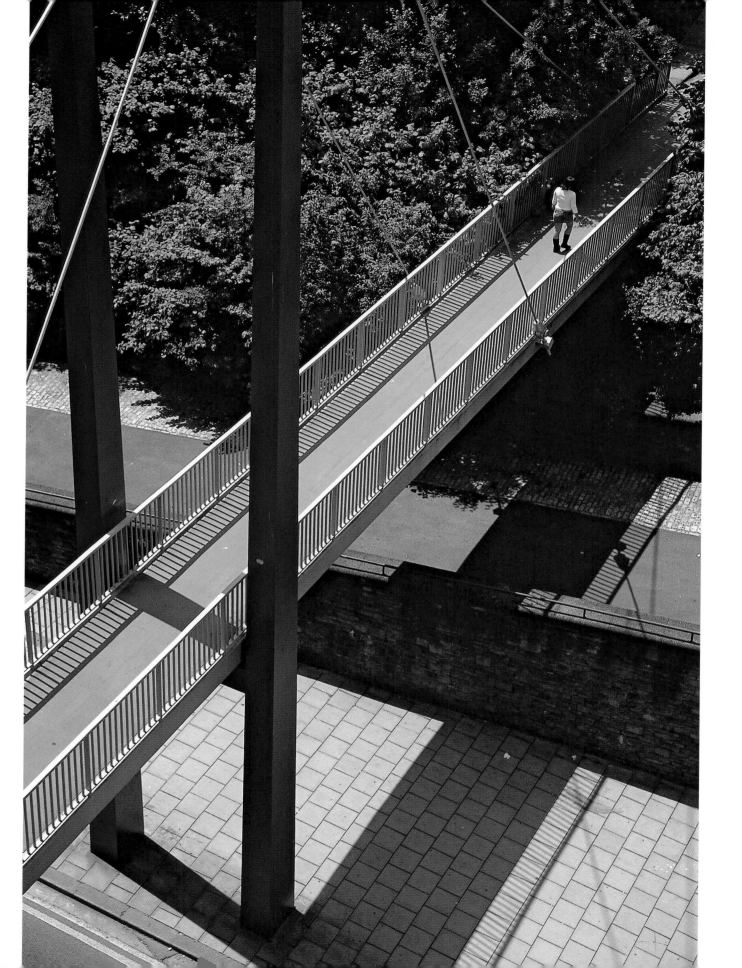

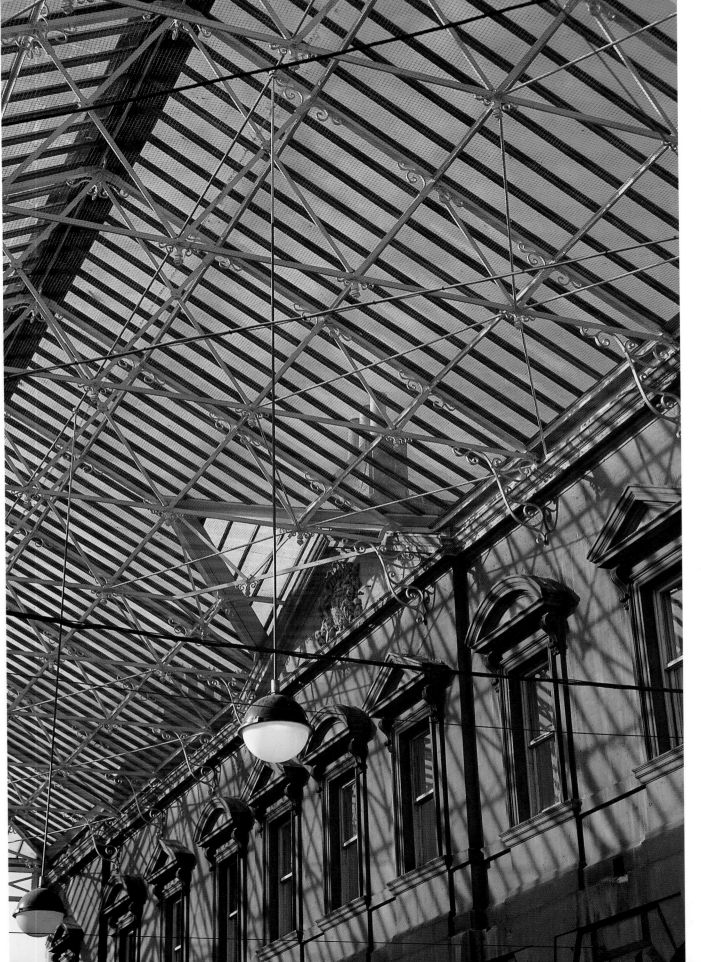

LEFT Samuel Glascodine's 1740s St Nicholas Market is enlivened by R.S. Pope's 1850s Glass Arcade.

RIGHT Henry Masters's lugubrious elephant on his pub of 1867, on St Nicholas Street behind John Wood's Exchange and the Markets.

FAR RIGHT Market stalls in Pope's Glass Arcade behind the Exchange.

BELOW RIGHT The city crest in the pediment of Henry Williams's 1903 Stock Exchange – now an Indian restaurant.

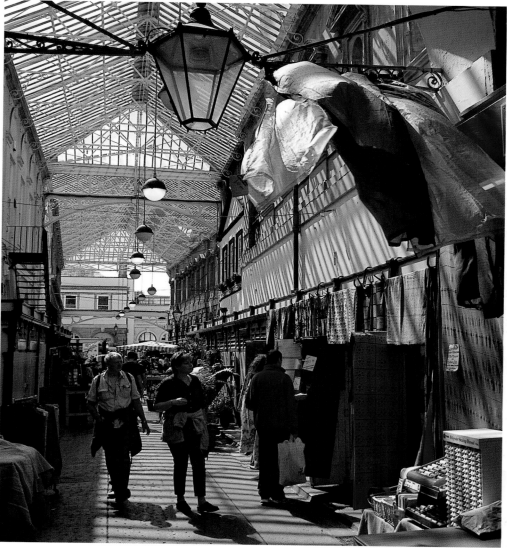

What survived, largely by the accidents of the bombing, was not the medieval or even the eighteenth-century city, but a nineteenth-century financial quarter of unfashionable charm and a treasury of rich detail. A slow walk along Corn Street and St Nicholas Street, looking without preconceptions about what is beautiful, will be most rewarding. Starting where St Nicholas leaves the ravaged High Street, the butch Romanesque of St Nicholas Chambers, by Archibald Ponton of 1866, is writhing with stone dragons more linearly inventive than any church gargoyles. The Elephant pub next door has a lovely carved floral frieze and on the convinced Ruskinian Gothic of Gresham Chambers by Ponton and Gough of 1868, there are the detailed heads of Roman emperors in roundels. On the gleaming black marble front of Henry Williams's 1903 Stock Exchange sit two shamelessly sentimental cherubs, one representing Justice, the other, equally improbably, Enterprise. The Art Nouveau tiles within are of high quality. Around the corner, 37–39 Corn Street has two moving bursts of Art Deco sculpture with Hermon Cawthra's wilting goddesses and a tense grid of dancing girls in 'anodium metal' over the doors.

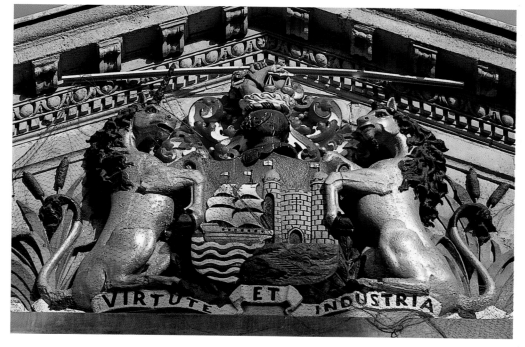

LEFT The shock of the new in 1743 – Palladian proportions imported from Bath in Wood's Exchange.

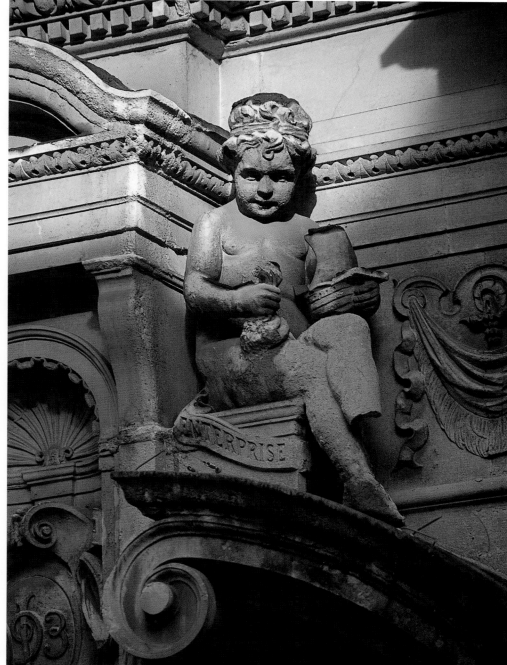

BELOW The Enterprise cherub, holding a ship and a moneybag, on the former Stock Exchange.

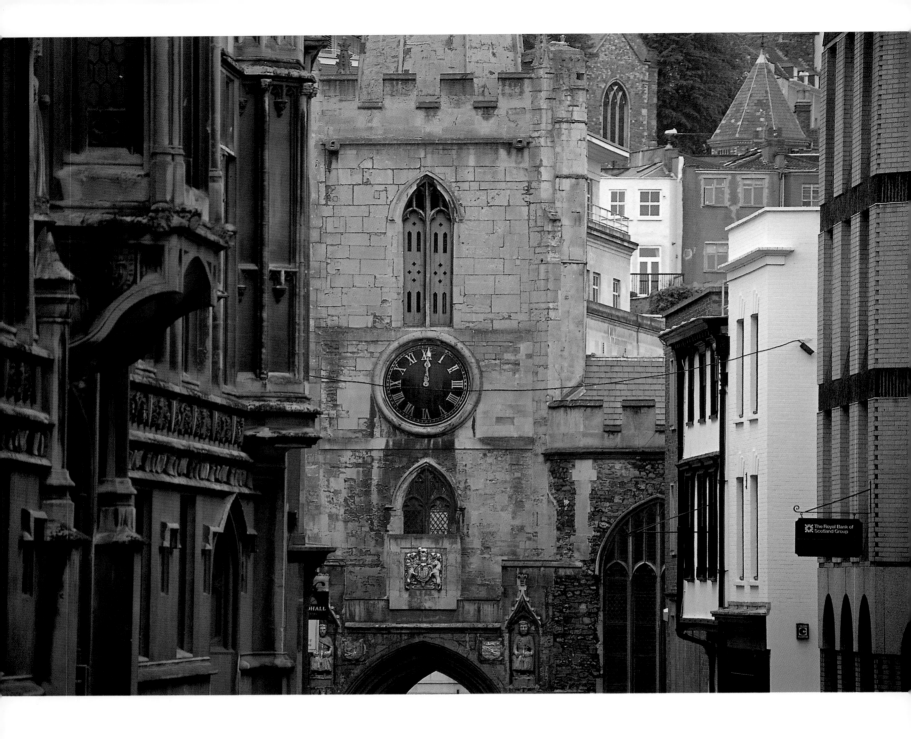

ABOVE St John the Baptist at the end of Broad Street, the last surviving church of four that once sat on the city gates.

TOP RIGHT Demure caryatids support the weighty pediment within a pediment of William Bruce Gingell's 1864–7 Globe Insurance Building on Corn Street.

RIGHT A glimpse from All Saints Lane of John Evan Thomas's Sansovinian sculpture on the former West of England and South Wales District Bank, now Lloyds Bank.

FAR RIGHT One of the 'Nails' for ringing true coinage outside the Exchange.

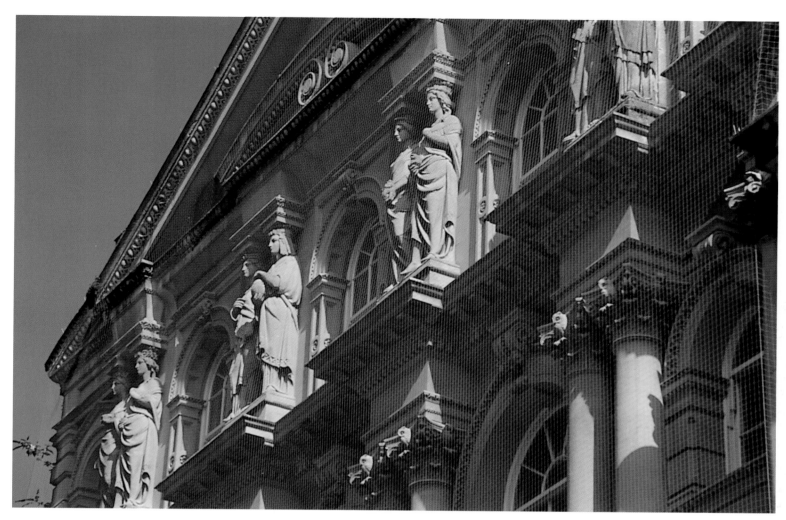

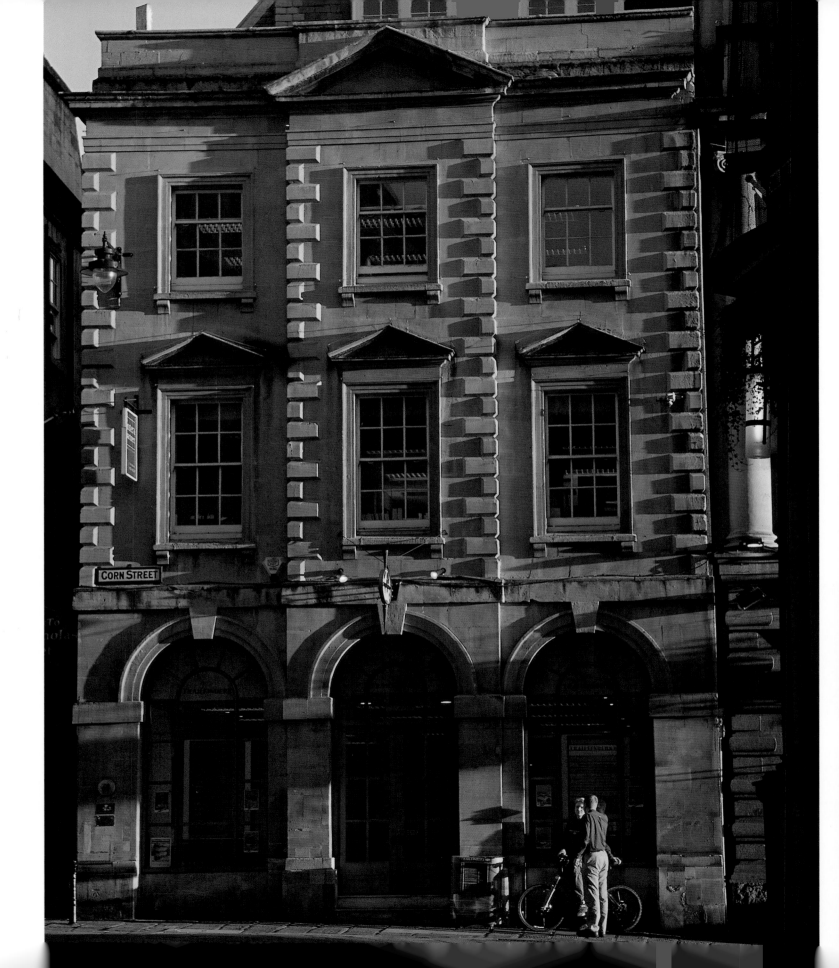

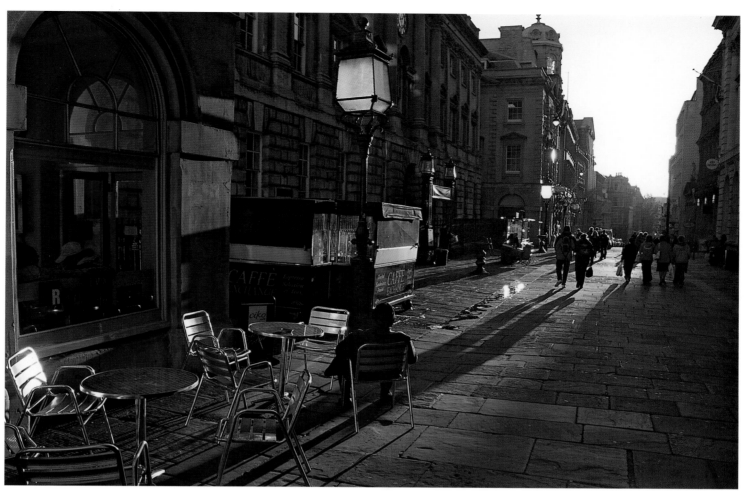

LEFT Samuel Glascodine's Post Office of 1746, sited to the right of the Exchange.

TOP Evening light in Corn Street, after the Wednesday farmers' market.

ABOVE A 'Wrenaissance' green man on E. Henry Edwards's former County Fire Office of 1899.

RIGHT A sinuous Art Nouveau sign on the former London & Lancashire Assurance Building by Edward Gabriel, 1904 – now an Italian restaurant.

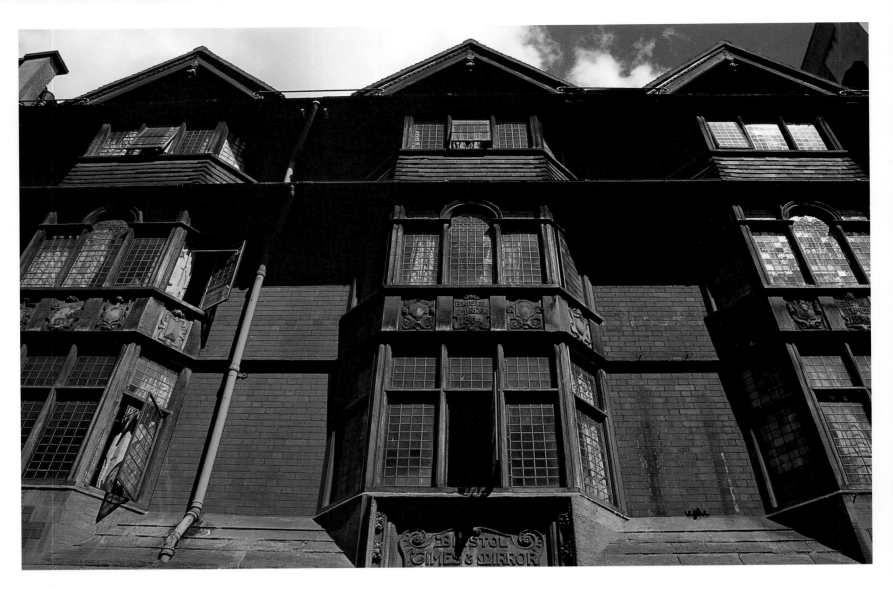

Bristol has long had a tradition of decorative craftsmanship that Bath, for all its advanced Palladian elegance, never developed. John Wood the Elder was brought over from Bath in 1741 to design the Exchange for the rival city in Corn Street, but it is obvious that, when the local Paty family's craftsmen were allowed in for the decorative detail, Wood's austere correctness was forgotten. Up on the supposedly scholarly Corinthian frieze of the Exchange Thomas Paty, the 'ornament carver', added a turbaned Turk's head, an Indonesian queen, an Indian in feathered headdress, horses, a camel and sea lions, while the Market within has a riotous Rococo frieze of womens' heads, shells, fruit and flowers, and plasterwork overdoor panels with the wild beasts and savage men of Asia, Africa and America.

As the ultimate blast of undervalued public carving, Lloyds Bank across the road from the Exchange, designed in 1854 by W.B. Gingell and T.R. Lysaght, has three bands of carving, by John Evan Thomas, which, if they could be discovered buried near some Periclean Greek temple, would be hailed as national treasures with a special gallery constructed for their display

in Athens. Here in Bristol they are valued as a mild sculptural joke. Men support the bottom tier as miners, shipwrights and engineers, separated by the prows of ships. Women hold the middle tier, active in good works, child care and charity. Above them all the children preside, playing with a naughty grace and mischief on a rich cornice frieze. It is a masterpiece, but in nineteenth-century Bristol one among many, all generally unnoticed.

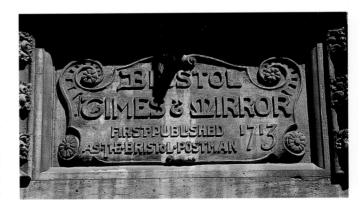

ABOVE LEFT Arts and Crafts canted bay windows recalling seventeenth-century Bristol merchants' houses light the former *Bristol Times & Mirror* offices (1902–4) on St Stephen's Street.

BELOW LEFT Victorian and Edwardian commercial buildings were proud to proclaim their heritage and their function in decorative inscriptions.

RIGHT The legendary founders of Bristol, Brennus and Belinus, are set on either side of St John's Gate. Belinus has recently been scraped of his decorative colouring.

We can add to this prodigy of detail such stars as the Georgian towers of All Saints and Christ Church, the Perpendicular Gothic of St Stephen's, the 1900–1901 Art Nouveau ceramic front of Everard's Printing Works in Broad Street, the thirteenth-century bastion tower of the old town walls hidden in a back courtyard of St Nicholas's Almshouses on King Street, Ponton and Gough's 1869 phenomenal polychromatic Granary warehouse towering above Welsh Back, and the overwhelmingly picturesque 1664 Llandoger Trow Inn on Little King Street, a relic of Bristol's lost vernacular half-timbering. That still leaves two churches of national importance. St Mary Redcliffe's Victorian spire almost pulls the entire lower city together. Within it is a slick, curiously crowded, cathedral in miniature, not quite to scale. But it has the most inventively beautiful, almost oriental, Gothic porch in Britain. In the room above the north porch the eighteenth-century boy poet Thomas Chatterton claimed to have found the Rowley poems. The real Bristol Cathedral was called by Henry VIII to fulfil that role though it had only been built as a daringly inventive choir for the Augustinians with a diminutive Norman nave for a congregation. Abbot Knowle's 1298 hall-church has a theatrical elegance of vaults within vaults – an ingenious way of avoiding the flying buttresses that can distract the eye from the most solemn service. Whether the Victorians were right, when they came to rebuild that little Norman nave, to imitate the hall-church design and do without a triforium and side-aisles is questionable. A concert hall nave lacks mystery, but is otherwise functional as a Protestant preaching space.

LEFT An eclectic range of façades, dating from the eighteenth century to the twentieth, on Broad Street.

RIGHT The polychromatic brick front of Gingell's 1894 building for Bigwood fish merchants on Baldwin Street. It is now a pub.

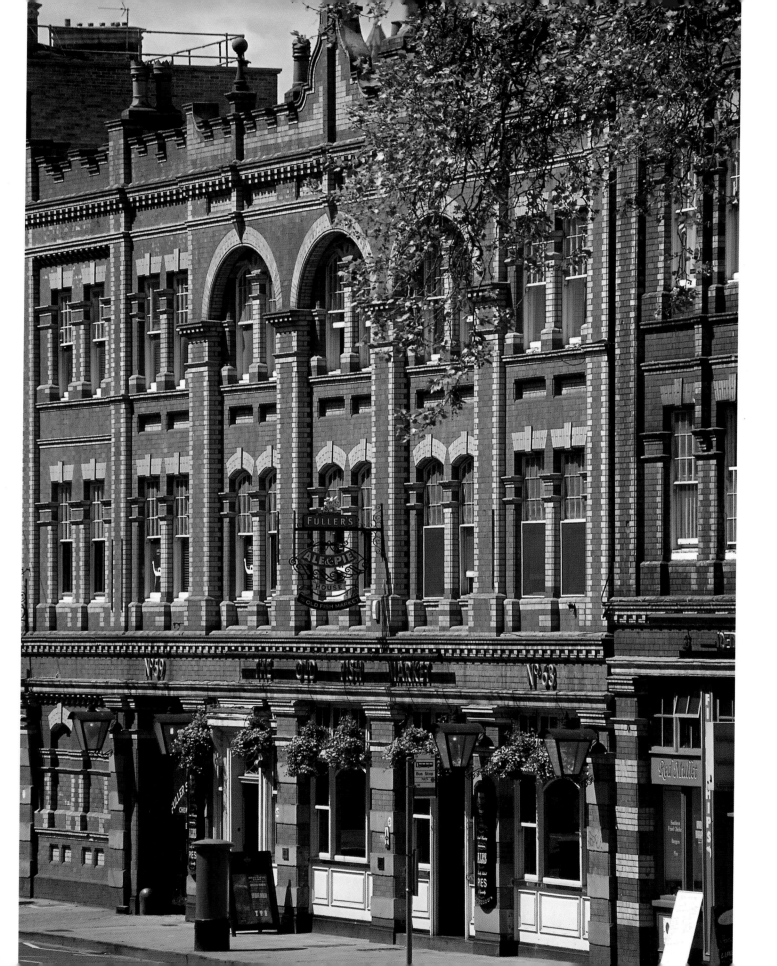

BELOW LEFT Buildings of the seventeenth, eighteenth and twentieth centuries range down Colston Street to the Colston Tower on The Centre.

BELOW CENTRE John Foster, merchant and Mayor of Bristol in 1481, peers out from Fosters chambers in Small Street – a Victorian response to one of the city's famous sons.

BELOW RIGHT A bewigged barrister guards the main entrance to the Assize Courts on Small Street.

RIGHT The river front of Number One St George's Square by Atkins Walters Webster (2001–2) is a brash attempt to echo the Bristolian warehouses of the nineteenth century.

FAR RIGHT Where medieval Bristol meets Victorian philanthropy – St Bartholomew's Hospital and Christmas Steps, with Fosters' Almshouses of 1861 above.

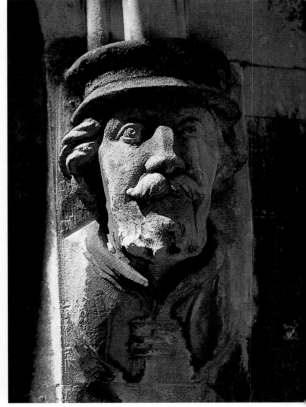

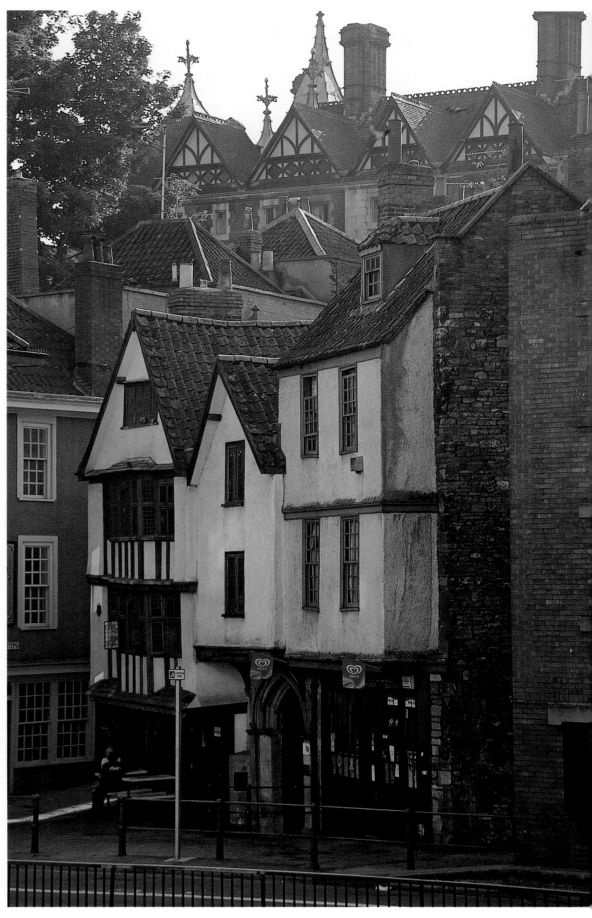

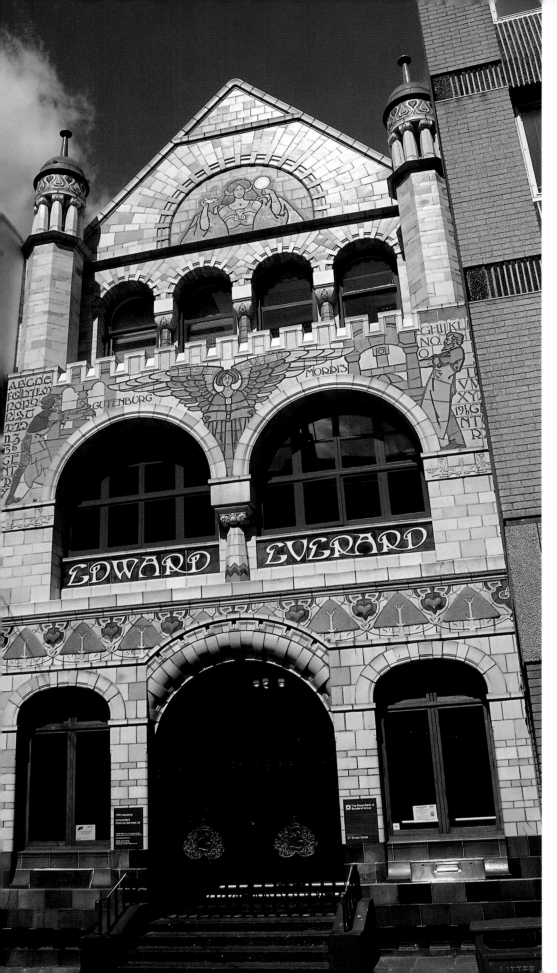

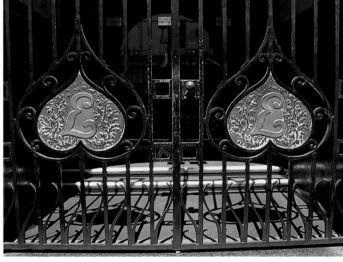

LEFT AND ABOVE **The typefaces of William Morris and Gutenberg, personalized for Everard's printers, feature on the faïence façade of Everard's Broad Street printing works, by W.J. Neatby. Everard's intials, set in the same typeface in repoussé copper appear within Art Nouveau hearts on the wrought-iron gates.**

OPPOSITE **The tower of Christ Church, rebuilt by William Paty in 1786–90, with earlier (1728) quarterjacks by James Paty.**

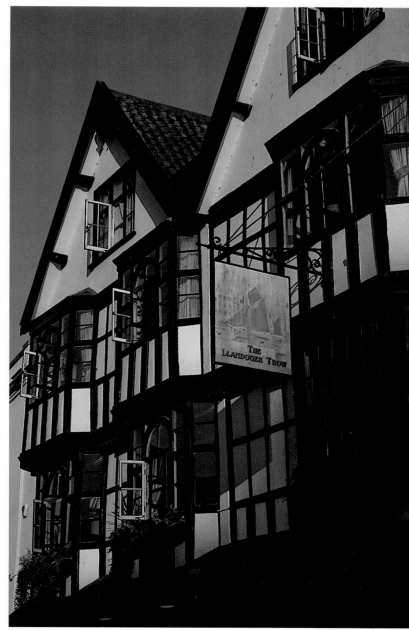

LEFT Archibald Ponton & William Venn Gough's 1869 Granary warehouse on Welsh Back – Tuscany imposed upon Bristol via the writings of John Ruskin.

BELOW The timber-framed bays of the seventeenth-century Llandoger Trow inn on King Street.

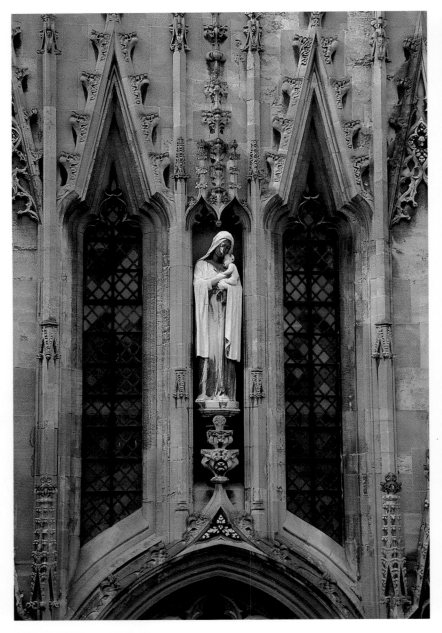

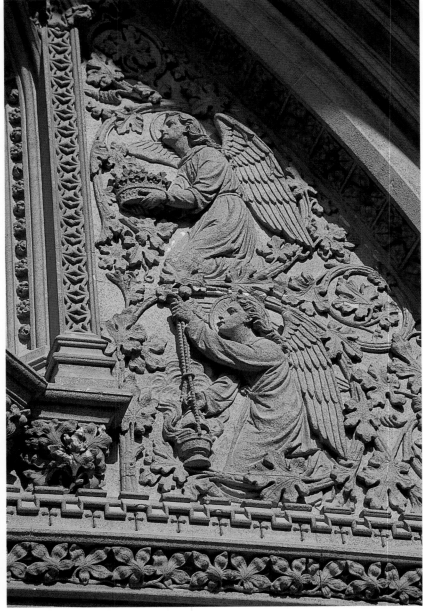

OPPOSITE, FROM TOP LEFT
The Virgin and Child beneath
the sharply pointed and
crocketed aedicules of the
mid-fourteenth-century south
porch of St Mary Redcliffe;
High Victorian angels give
praise to an empty niche on
Street's west portal of the
Cathedral; Grinning mythic
beasts on the 1320 north
porch of St Mary Redcliffe.

RIGHT A muscular wrestler
with clawed hind feet and
lizard tail on St Mary
Redcliffe's north porch.

BELOW Pious and studious
Victorian figures on the tower
of St Mary Redcliffe.

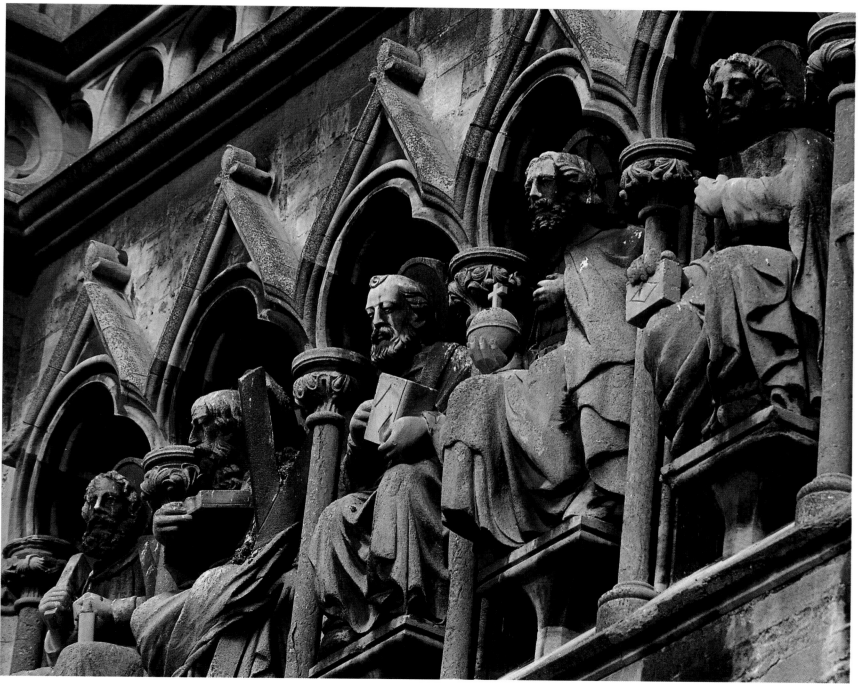

BELOW Vines and birds flourish on the very last great Gothic Revival civic building in England – the Wills Memorial Building, designed by Sir George Oatley in 1912 and completed in 1925.

RIGHT A bridge of chunky maritime profile.

FAR RIGHT John Doubleday's 1985 *Phoenix* on the Portwall.

BELOW RIGHT The north side of King Street, the surviving heart of the maritime city, with warehouses, almshouses and the former Cooper's Hall (by William Halfpenny, 1743), now the Theatre Royal.

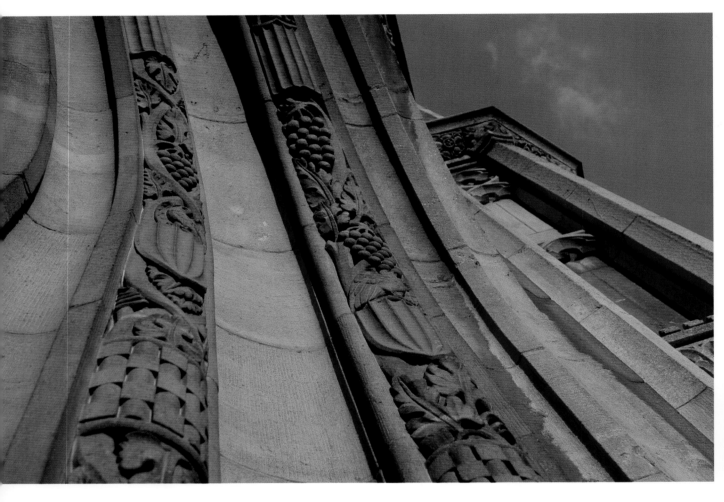

Easily the best way to absorb the Old City and Bristol's provincial but humane tradition of domestic building is to concentrate on King Street. This has everything post-1650: two sets of almshouses – St Nicholas's of 1652 looking backwards, and the Merchant Venturers' of 1696 looking tentatively forwards. Several of the brick merchants' houses teeter between Queen Anne and King George in date; William Halfpenny's Cooper's Hall of 1743 demonstrates how not to handle the Palladian, while 35 King Street is the prettiest Bristol 'Byzantine' warehouse surviving in the city, an 1870 design. Hidden behind all this coy charm is the Theatre Royal, usually claimed to be Britain's oldest working theatre. It was built in 1766, by the Patys, to a design by the Drury Lane carpenter, John Saunderson, but its frivolous auditorium presents a permanent handicap to the Old Vic company when it tries to present Greek tragedies or Eugene O'Neil in its light-hearted spaces.

King Street and the Old City around Corn Street combine to make a tourist's treasure that tourists have somehow always forgotten. Bath has distracted them with its more obvious charms. Bristol is for bankers, lawyers and businessmen. Long may it remain that way.

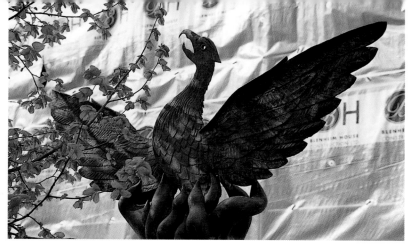

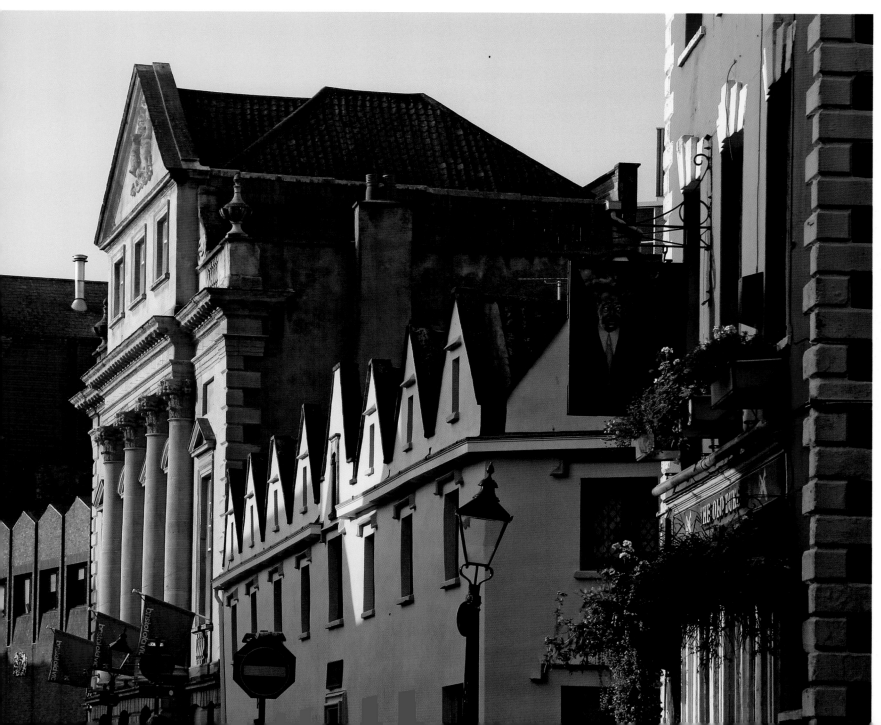

kingsdown: private enterprise storms the heights

As will have become apparent from the previous chapter, give or take a few medieval churches and fragmentary townhouses, the Old City of Bristol is largely the result of nineteenth-century competitive commercialism and civic pride. It is, therefore, the most recent historic building area of the city. Cut off from this Victorian core by the ruthless band of Temple Way, the inner ring road, there are substantial relics of eighteenth-century Bristol's polite residential areas in Brunswick Square and Portland Square. Brunswick Square is not impressive. It was laid out in 1766 by George Tully, and rose piecemeal over the next twenty years. Tully had laid out Dowry Square, in the Hotwells, much earlier, in the 1720s, and the Brunswick elevations, whether by Tully or, as in most cases, the Patys, Thomas and William, have the same hangdog look of Quaker brick simplicities, with the Patys' added trademark of stepped voussoirs over the windows. Portland Square, by Daniel Hague, is later, of 1787–8, and it is faced with Bath stone and altogether more elegant; but its centrepiece, Hague's St Paul's church, would have branded the development in the eyes of any visitor from Bath or London as unsophisticated and provincial. With its telescopic succession of diminishing stages to the tower and the thin Gothick overlay of panels on its surfaces, the church has great presence, but it is hard to describe it without a measure of condescension. It is a cardboard cut-out composition and Hague was an untutored improviser, a typical Bristol designer.

What is interesting about Brunswick and those Tully-style brick ranges is the difference between the way that Tully's Hotwells buildings developed as they climbed the hill behind them up to Clifton and the way the city ranges developed as they scaled the heights behind them up the King's Down. In Clifton the early brick classical terraces matured into impressive squares and terraces of stone, on Kingsdown they have produced a free-for-all of individual brick houses shouldering each other on two long streets. Kingsdown Parade is on the very topmost edge and Somerset Street a little further down the slope. On both streets, though chiefly on the west side of the Parade, attempts were made to impose a terrace discipline, but the results are best described as an enjoyable chaos.

The reason why Clifton matured and flourished while Kingsdown collapsed into a curious classical picturesque is that Clifton was controlled and directed by the landowners, the Society of Merchant Venturers, while Kingsdown's houses were built to please individuals or, in the case of the terrace of eleven houses at the north end of the Parade, as a venture by a private developer. The Society of Merchant Venturers often gets a grudging and suspicious bad press. Its members are seen as a semi-secret society, Bristol's second but unelected councillors, the puppet masters tugging at the strings of power. But if ever there were a Nobel Prize awarded for aesthetic urban achievement then the Merchant Venturers would be in line for one: for their salvation of the city's image by the construction of the Floating Harbour; and for the vision and control which they projected to create in Clifton one of the great European suburbs, as life-enhancing and spatially thoughtful as Seville's Barrio de Sta Cruz.

RIGHT **Featureless office blocks around the brutal Temple Way – a city ravaged by its transport needs.**

BELOW St Paul's, Portland Square – provincial Gothick of naïve charm and striking wedding cake profile.

RIGHT A uniformity of classical domestic style, from Georgian St Paul's to the Regency and later heights of Montpelier.

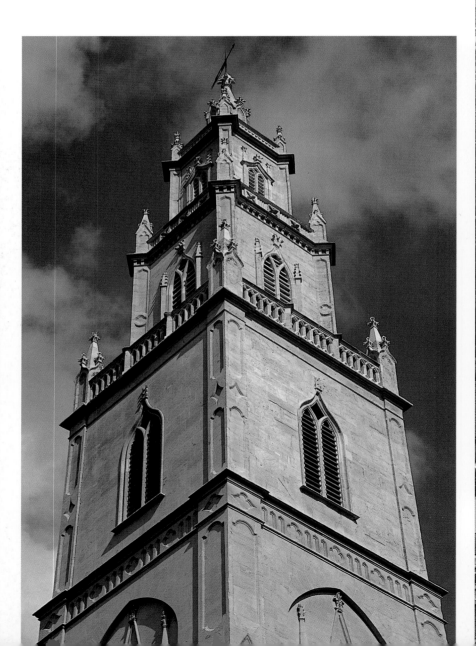

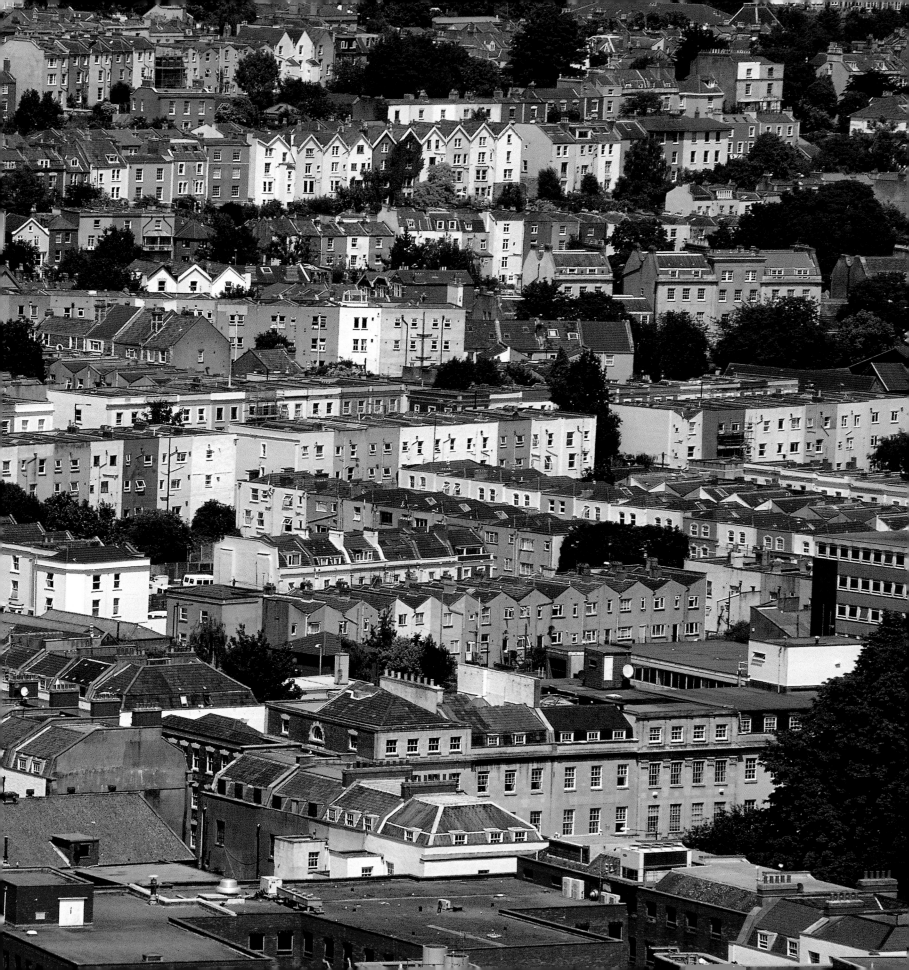

RIGHT Georgian speculative
housing on Kingsdown
Parade, with its livery of
colour-washed stucco and
stepped voussoirs.

BELOW A heritage street
lamp and protective tiles on
Somerset Street, Kingsdown.

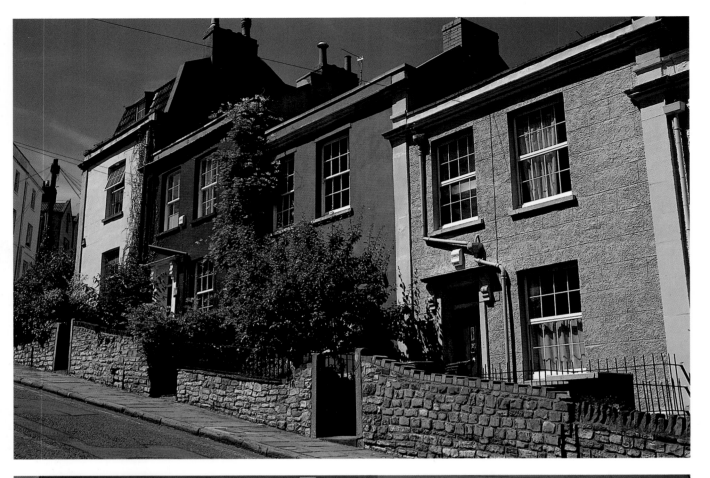

ABOVE LEFT **Late Georgian classicism steps easily downhill and down the class structure on Nine Tree Hill, Kingsdown.**

BELOW LEFT **The Paty livery of stepped voussoirs above sash windows in Kingsdown.**

RIGHT **The Dove Street flats remain the most grievous single error in Bristol's chequered post-war planning history.**

Because Kingsdown presides so visibly over the Old City and because most of its houses predate those of Clifton it deserves to be studied and enjoyed first in order to understand what went wrong yet what has ultimately resulted in a fascinating sequence of good intentions. But first one shocking loss must be recorded. This is Bristol's greatest single visual disaster in all those postwar years of idealistic stupidity when 'towers in the sky' were considered the kindest way to solve the working-class housing problem. Until 1965 all that steep hillside of Kingsdown, that hangs like a breaking wave over Stokes Croft, Jamaica and Dighton streets, was a most movingly various Georgian suburb, half-way between Heaven and the Old City. The jostling variations of Somerset Street had spilt down the hill in little headlong lanes and flights of steps – Montague Hill, Spring Hill and Dove Street – a jumble of bay windows, gardens, columned porches and tangled rooflines. Scraps of it remain, but the City Architect's Department put up, between 1965 and 1968, three featureless, fourteen-storey blocks of flats, out of all scale with the hill, to wreck that perfect neighbourly place; it was an inexcusable folly.

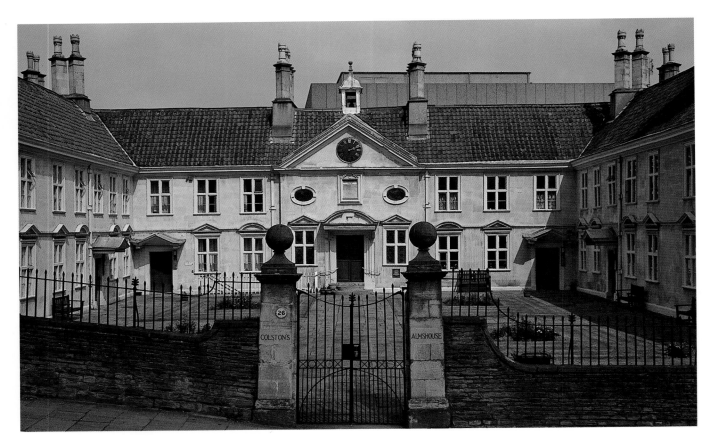

The unpredictable façades of Somerset Street and Kingsdown Parade, for all their charm of Gothick-glazed Venetian windows, cottages converted to gentry status and Patyesque stumbling terraces, are nagging reminders of civic blindness and planners' blight. Just to walk the lower of the two roads and then, at the simple, colour-washed elegance of Freemantle Square, to turn up and walk back along the Parade is a rare urban pleasure and a revealing insight into the rewards of ham-fisted private enterprise. On its garden side the Kingsdown Parade houses overlook the city, while their street-side elevations, being on the crest of the hill, look across the narrow cobbled road into one of Bristol's most hit-and-miss yet attractive urban vistas: a broken rhythm of Patyesque brick façades enriched by two-and-a-half centuries of improvisations and all approached, most unusually, up long front gardens via pedimented arches in their garden walls. This weird, organic terrace has no back gardens at all. Instead, what were the servants' back doors to all the houses are now their official front doors on a faintly squalid 'Back of Kingsdown Parade' street.

After this pleasantly textured confusion it is a revelation to move one block to the west to enjoy High Kingsdown. This is a very moral, Danish in feeling, experimental housing estate by Whicheloe Macfarlane and J. T. Group Limited of 1971-5. Its intensely neurotic herringbone of pale orange brick offers the privacy of an enclosed garden to every house. at the cost of endless tall, blank walls facing the walkways. An inspired planting programme of often rare and attractive bushes and climbers does much to soften the discipline. David Mackay

was the architect and as an urban solution it is, at the very least, thought-provoking, utterly the reverse of the faults and virtues of Kingsdown Parade.

At its western end the alleyways of High Kingsdown open up on to St Michael's Hill, and here it is impossible to pass without comment on the architectural legacy which the University of Bristol has heaped upon its native city and the strategic hillside on which its buildings stand. Sir George Oatley was a very Bristolian phenomenon: an architect determined to design in a style that the rest of the country had given up years before. He produced a romantic and imaginative proposal to crown Tyndalls Park with a ring of towers like a modern-day Camelot. A few of the towers got built, but the scheme was abandoned

ABOVE LEFT **Late-seventeenth-century vernacular forms striving towards polite classicism in Colston's Almshouses.**

BELOW LEFT **A row of seventeenth-century timber-framed houses at the foot of St Michael's Hill.**

ABOVE RIGHT **The University of Bristol's magisterial H.H. Wills Physics Laboratory stands above the later chaotic development.**

BELOW RIGHT **Science in Gothic Revival garments – Oatley designed the Physics Lab to be one of twelve medieval-style towers ringing the hill.**

FAR RIGHT **Bronze sunbursts on the mullioned and leaded Physics Lab.**

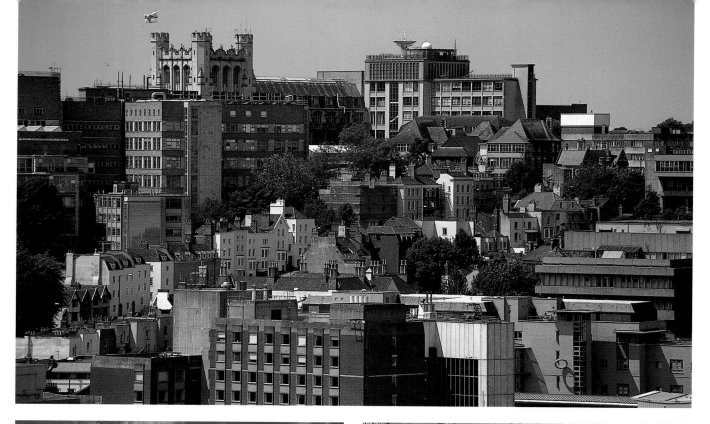

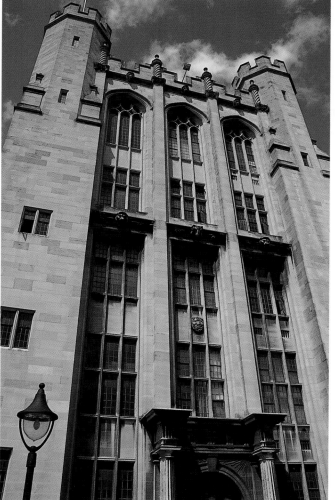

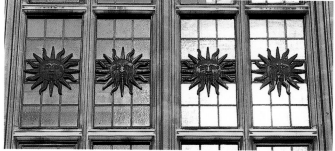

through lack of funds and since then the University has never been able to decide upon its visual image.

St Michael's Hill was, until the University settled on one side and the Maternity Hospital on the other, an amazing survival: a veritable Clovelly of picturesque gabled houses, with Colston's Almshouses of 1691, like some Cambridge College quadrangle, and St Michael's church, a Paty attempt at Gothick of 1775, all of them lining an impossibly steep road. The Maternity Hospital wrecked the east side with a thoughtless grey slab when the existing building line could easily have been preserved. As if that were not philistine enough, the hill rises up to Tyndall Avenue and the University Library of 1975, by Twist and Whitley, styled in a depressed Brutalism which, nevertheless, won a design award. It is one of four campus-style blocks built for the University on that side of the road, not one of which relates to its neighbour or to Oatley and Lawrence's 1921–7 Physics Laboratory, a functional Tudor Gothic tower of stately beauty. It is as if the University was completely at a loss once the guiding lines of the Gothic Revival had been removed and modernist freeform took its place.

clifton: heights not stormed but controlled

To reach Kingsdown from the city the roads are narrow and as steep as the roofs of the houses; to reach Clifton from the city the route is wide, solemn and almost ceremonial. That marks the difference between a private enterprise suburb and one firmly disciplined by the Merchant Venturers.

It has to be admitted from the start that Clifton was given the more impressive launch pad. It is approached from the Old City through College Green. This triangular space is overwhelmed by two buildings – the Cathedral and the Council House – which conspicuously fail to relate to each other. Though it has a fine central tower and a richly articulated Norman and Gothic Gatehouse, the Cathedral, being a hall-church, lacks the attractive play of levels that lower aisles would have afforded. As for the Council House, a sub-Lutyens composition begun in 1938 to E.Vincent Harris's derivative design, its bulky brick crescent bears down upon the flat College Green like an affluent grinning mouth. It makes no reference to the Cathedral or to Charles Holden's 1902 Library or to that rich antique shop of funerary monuments the Lord Mayor's Chapel. The central statue of the Council House, John Cabot by Charles Wheeler, is tame, and only the golden unicorns on the roofline have panache. It is, however, undeniably an edge of a kind, a conservative echo of Clifton's terraces and an insistent visual demarcation line which no one can ignore.

Park Street rises up the hill from College Green between regular, Bath stone classical façades with the even more cor-rectly Neoclassical villas and terraces of Great George Street and Charlotte Street branching off to leafy parkland on the left. All these streets are part of the pre-Napoleonic War building boom, any date from 1758 to the late 1780s. The monster Gothic tower of the University's Wills Memorial Building is, of course, a much later afterthought, of 1915–25, the centrepiece of George Oatley's vision of an academic Camelot which would

give the new University an architectural signature to rival Oxford and Cambridge.

Oatley's tower probably did exactly what he intended. Like it or loathe it, the building is impossible to ignore, but it heralds something much stronger than a mere university. On the level ground at the top of the hill a rival and successful Bristol city centre was created in the years following the terrifying arson attacks of the 1831 Reform Riots; Oatley's giant stump was only the last of a series of civic buildings raised in order to move the city's whole centre of urban gravity up hill and westwards away from the turbulent lower classes living down around the industrial areas by the harbour. This was when Clifton became Bristol's senior partner, the suburb in charge of the city.

ABOVE **Fathers of the Church on the north porch of Bristol Cathedral.**

ABOVE RIGHT **An uneasy stylistic trio on a strategic corner of College Green – Cathedral, Public Library and Council House.**

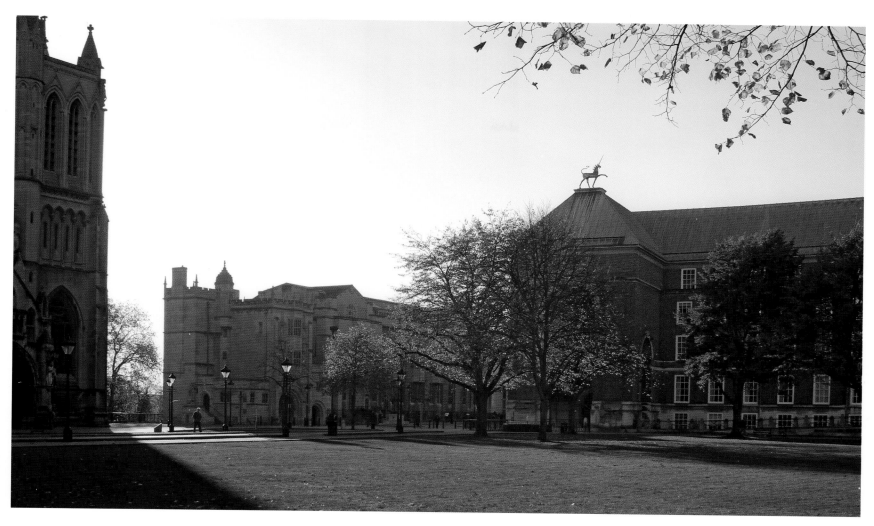

Clifton had always offered the attraction of fresh air in a much-polluted city. Back in the 1780s the Merchants had hoped, via a deep bore hole and a pump, to elevate the Hotwells spa spring up to a row of bowed and canted-bay lodging houses on Sion Hill. The saline spa water was to be piped into the surrounding houses as an inducement to build. In the event the source dried up completely, but there was still a surge of speculative building all along the heights. The outbreak of twenty-two years of war with France in 1793 put an end to that. Builders went bankrupt and entire housing projects, like those around Richmond Terrace, a Paty speculation of 1790, remained empty shells until after Waterloo. The real kick-start to Clifton as the place, not just for a few rich merchants to live in, but as the natural home of all middle- and upper-middle-class Bristolians, came with the Riots in October 1831.

At the time they looked like a dress rehearsal for a British version of the French Revolution. Bristol had always been ruled by a drunken and selfish elite of aldermen and councillors, so when the prospect of a Reform Bill with a wider franchise seemed threatened by local conservatism and by the much-hated Bristol Recorder, Sir Charles Wetherell, a mob rose up and torched the city, incinerating the Mansion House, the

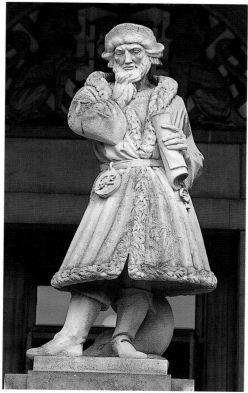

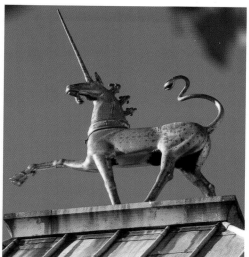

ABOVE **One of the two stiff-legged unicorns by David McFall on the roof of Vincent Harris's Council House.**

LEFT **The city's most famous explorer – John Cabot on the Council House.**

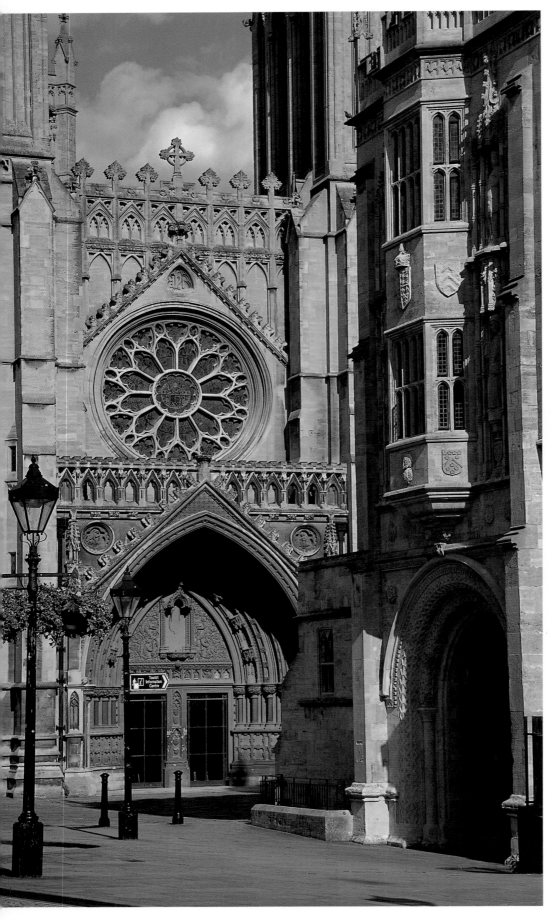

LEFT George Edmund Street's Victorian west front to the Cathedral, neighboured by the Norman and fifteenth-century gatehouse.

BELOW Niranjan Pradhan's 1997 statue of Raja Rammohun Roy, humanist and religious reformer, who came to Bristol in 1831.

RIGHT Until very recently a main road ran between the Cathedral and the Council House.

BELOW RIGHT Oatley's resoundingly confident Wills Memorial Tower, completed in 1925 and the icon of the University of Bristol.

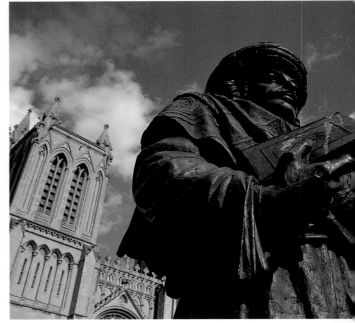

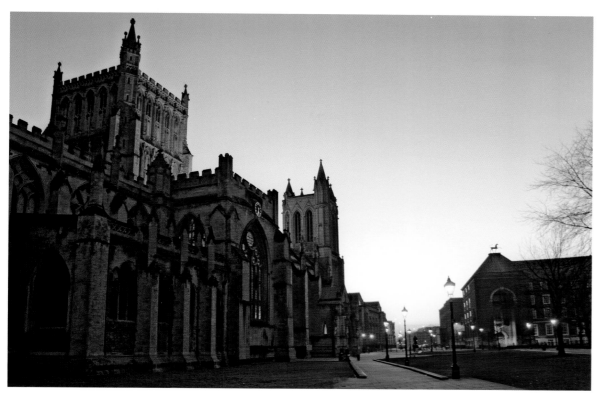

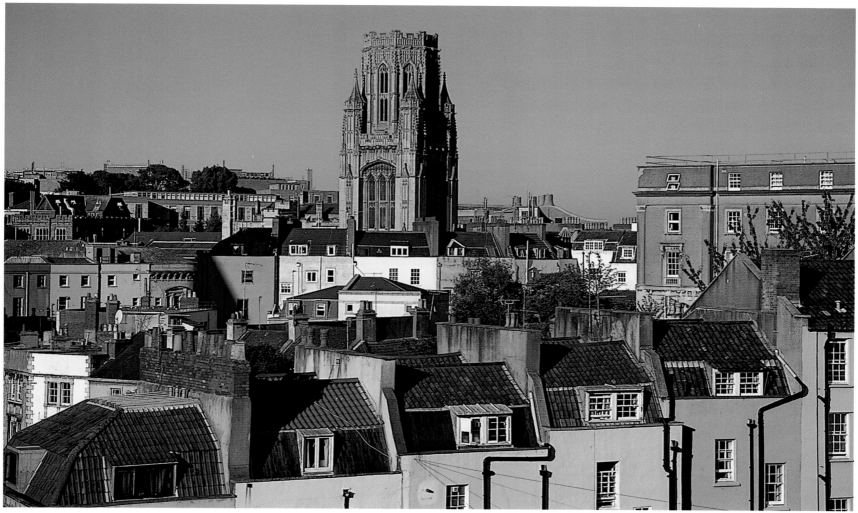

CLOCKWISE FROM TOP LEFT
Suitably skulking in the garden of the Red Lodge – Sir Charles Wetherall, Recorder of Bristol and catalyst for the Bristol Riots;

The giant Corinthian portico of the Victoria Rooms, designed by E.A. Rickards in 1910 and erected in 1913, seen from the Royal West of England Academy;

A sinister merman on the forecourt fountain of the Victoria Rooms; The Edward VII memorial statue in front of the Victoria Rooms.

OPPOSITE RIGHT Bayonet at the ready, the South Gloucestershire Regiment's South African War Memorial by Onslow Whiting, 1904–5.

OPPOSITE FAR RIGHT
Squalid urban decay around H.E. Goodridge's failed vision of a Catholic basilica for Clifton.

Custom House, much of Queen Square, even the Bishop's Palace. Three prisons were broken open, the prisoners were set free and, until the yeomanry were brought in, looting and drunkenness were widespread. The mob broke into the City Corporation's wine cellars and drank hundreds of bottles of port, sherry and madeira, many subsequently lying insensible in the awful conflagration. Some accounts record that at least five hundred were killed, but Sir Charles Wetherell, whose ceremonial arrival to conduct the legal Sessions had caused it all, escaped by crawling along the roof gutters of the Mansion House into the house next door where he disguised himself as a postillion.

After that the prosperous classes had had enough of living near their workplaces. Clifton, rather than Brunswick or Portland Square, became the place to live. As a splendid architectural seal upon the Heights as the superior social district, Charles Dyer was commissioned to build the Victoria Rooms between 1838 and 1842 as a place of assembly for concerts and balls. In the twentieth century the Rooms were used by the University as the Students' Union until they were abandoned in 1965 for its intrusive, slab-like new Student's Union on Queen's Road; they now house the Department of Music. The simple visual impact of Dyer's perfectly proportioned, eight-columned Corinthian portico still raises the spirits at this main entrance to the select suburb. On its pediment Wisdom in her chariot leads Aurora and the Graces, great bronze lions flank the steps and an Art Nouveau fountain of 1913 by Henry Poole pours generous water over dolphins and tortoises.

In between Oatley's tower for Camelot and Dyer's high-powered Roman temple – two conflicting icons – all the civic trappings that should have gone up around the ill-named Centre by the Harbour have been built on the edge of suburban middle- and upper-class Clifton. The gentry stole the city for their own self-gratification. Foster and Wood's shopping centre of 1859, the Royal Promenade on Queen's Road, was never matched in scale or prestige down in the Old City until the postwar reconstructions on the Broad Mead of 1950. J. H. Hirst's Royal West of England Academy of 1854–7, the now defunct Catholic pro-Cathedral of 1834–48 by Goodridge and Hanson, Frank Wills's 1900–05 Art Gallery and Foster and Ponton's brilliant evocation of Ruskin's Venetian obsession in the 1867–72 Museum and Library (now Brown's Restaurant) should all be in the city's real centre, wherever that is. They express perfectly the ill-directed but always enjoyable eclecticism of the High Victorian with their Italianate, Romanesque, Baroque and Gothic aspirations. It is typical of Bristol that they

ABOVE Figures of architecture, painting and sculpture by W.J. Smith sit on the parapet of Frank Wills' Museum and Art Gallery on Queen's Road.

LEFT Ruskinian Gothic on the former Lecture Theatre, by Stuart Colman, 1874, on University Road.

RIGHT Ruskin's Venice on the Queen's Road – Foster and Ponton's former Museum and Library, now Brown's Restaurant.

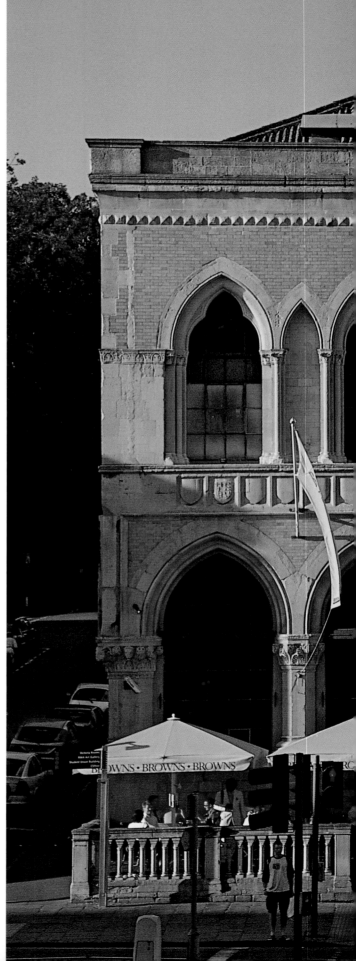

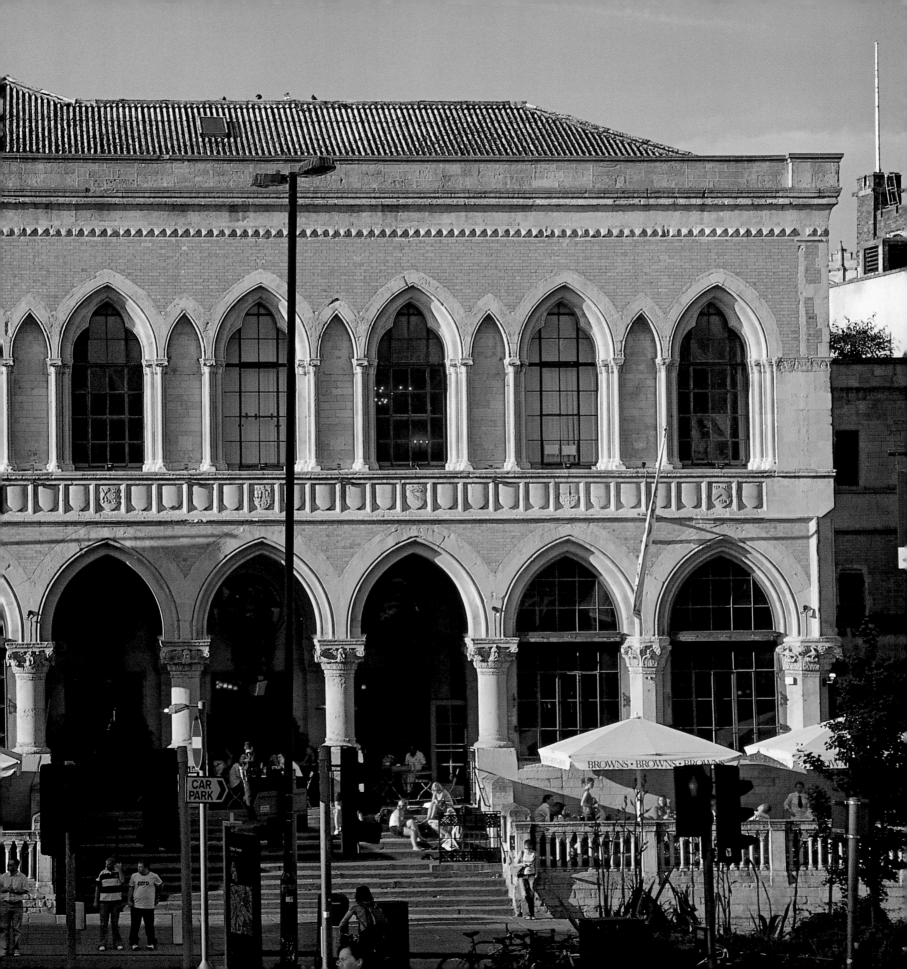

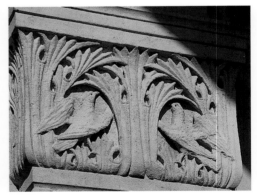

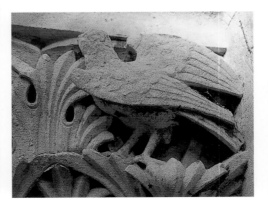

LEFT Spiky Early English Gothic tracery fused with Venetian Gothic capitals at Brown's Restaurant.

ABOVE RIGHT Rysbrack's triumphant King William III rides without stirrups in the centre of Queen Square.

BELOW RIGHT The hit-or-miss elevations of Queen Square – builders' rather than architects' classicism.

BELOW Victorian *architecture parlante* – decoration that speaks the function of a building, as here on the former Museum and Library, with monkeys, hedge birds and peacocks.

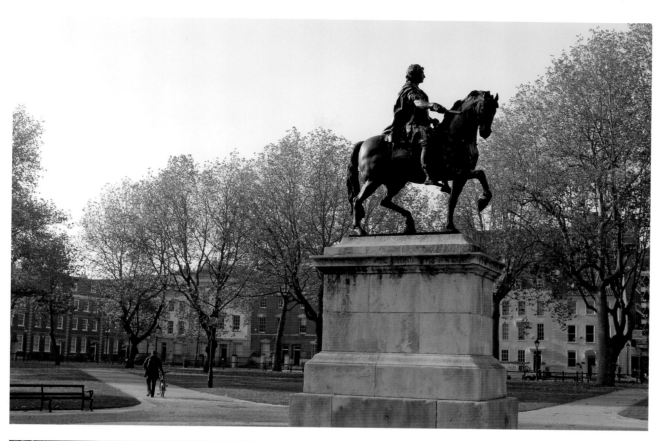

are all strung out along a street. Central Bristol never got round to building a major civic square even though it had been handling grand domestic squares ever since 1699, when Queen Square was laid out with its essentially civic and very beautiful 1733 statue by John Michael Rysbrack of William III looking winsome on horseback.

After such a discordant blast of loud architectural trumpets the real residential Clifton should come as no surprise. It is very grand, but uneasily varied. Pompous terraces like Vyvyan, by Richard Shackleton Pope of 1833, and Worcester, by Charles Underwood of 1848, are in entirely different styles but, being out of sight of each other, never clash. The biggest square, Victoria, has three sides, one Regency, one plumy Italianate and one Lombardic Romanesque in orange stone; the fourth side never got built, but splendidly mature cedars

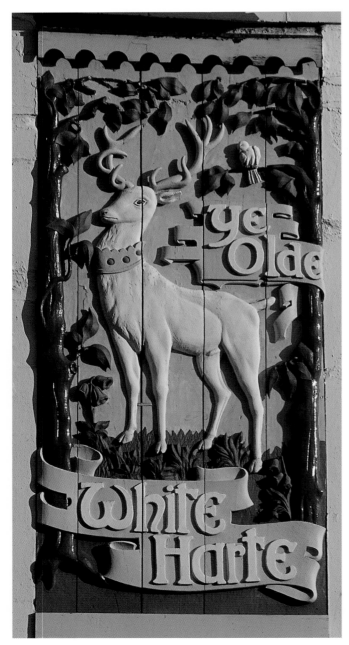

LEFT **The White Harte Pub on Park Row – Victorian commercial sign decoration at its best.**

ABOVE RIGHT **An octostyle Ionic loggia** in antis **at Vyvyan Terrace, Clifton – early Victorian classicism in hyperdrive.**

CLOCKWISE FROM ABOVE FAR RIGHT **Different styles for different sides of Victoria Square, Clifton – Italian palazzo, Lombardic Romanesque and Regency.**

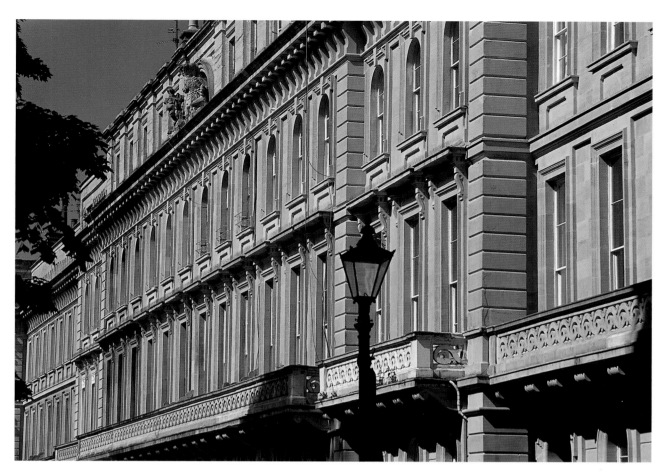

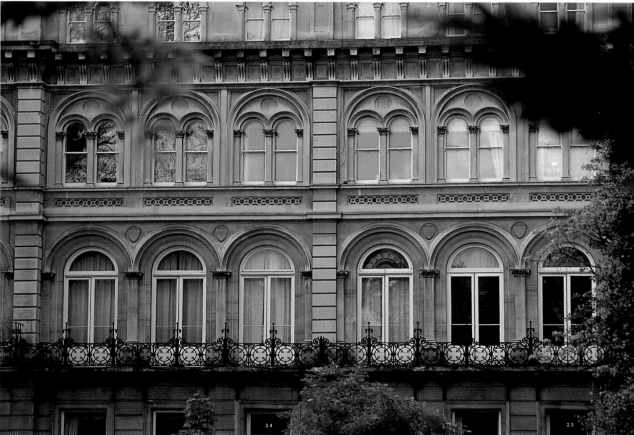

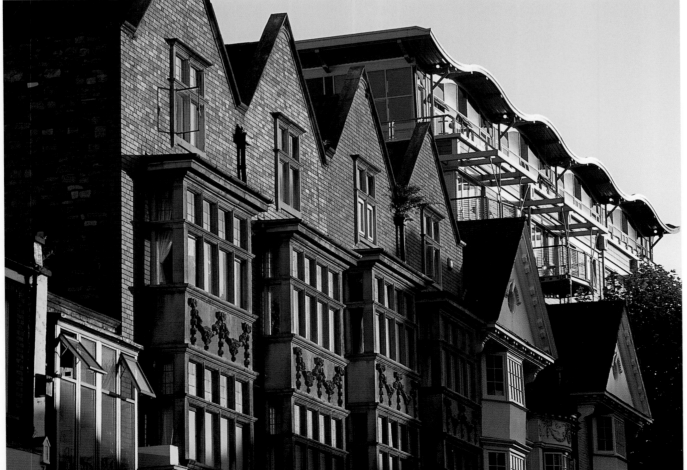

ABOVE LEFT Characterful shabbiness in Bristol's alternative shopping area around Park Row and Perry Row.

LEFT Arts and Crafts shops on Park Row, by James Hart and Edward Gabriel of 1902 and 1905.

ABOVE RIGHT Foster and Wood's 1859 Royal Promenade on the Triangle brought superior shopping uphill from the Old City.

RIGHT Artisan individuality in Cliftonwood.

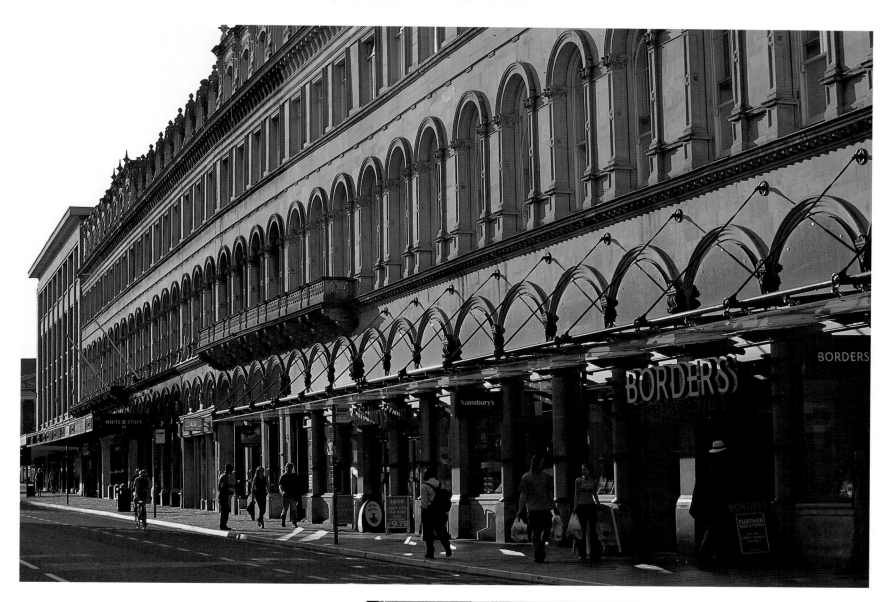

and specimen trees pull it all successfully together. From time to time, but in no sequence, an impressive church interrupts the horizontals: pure, slim Christ Church, outrageous Buckingham Chapel, by Pope of 1842, like a Gothic book-end, and – the twentieth-century's contributions – Clifton Cathedral of 1965–73, by the Percy Thomas Partnership, which gives the two thieves the same rating as Christ in its symbolic skyline, and All Saints, Pembroke Road, rebuilt after war damage between 1962 and 1967 to designs by Robert Potter. This hurls primitive John Piper glass against a High Church ciborium in a stylistic battle which W.H. Randoll Blacking's ciborium wins hands down.

ABOVE Mediterranean colours in Princess Victoria Street, Clifton.

FAR LEFT Clifton Village – Bristol's classical answer to London's Hampstead.

LEFT *Rus in urbe* at The Mall, Clifton's communal parading area.

ABOVE RIGHT Tented Grecian balconies enliven the predictable elevations of a typical Clifton terrace.

RIGHT An essentially southern city – a street party in Cliftonwood.

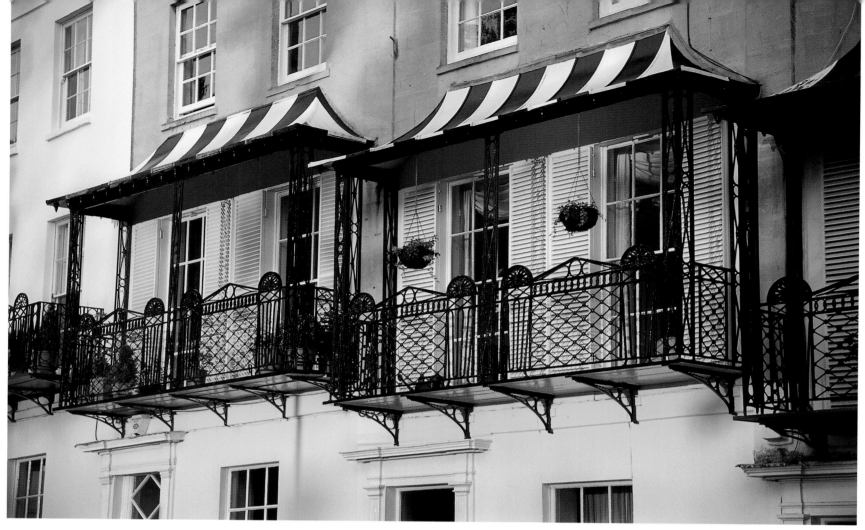

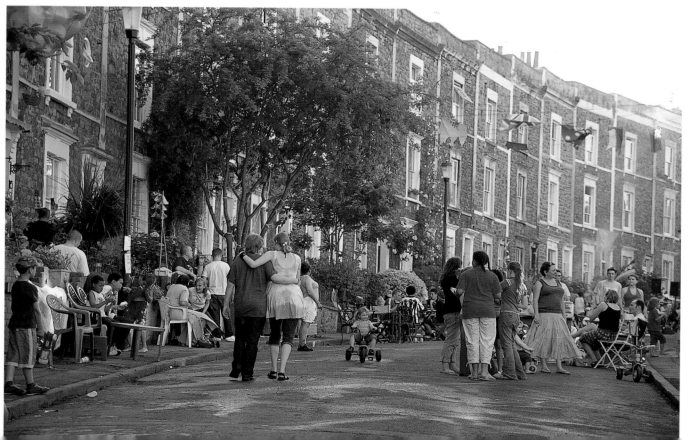

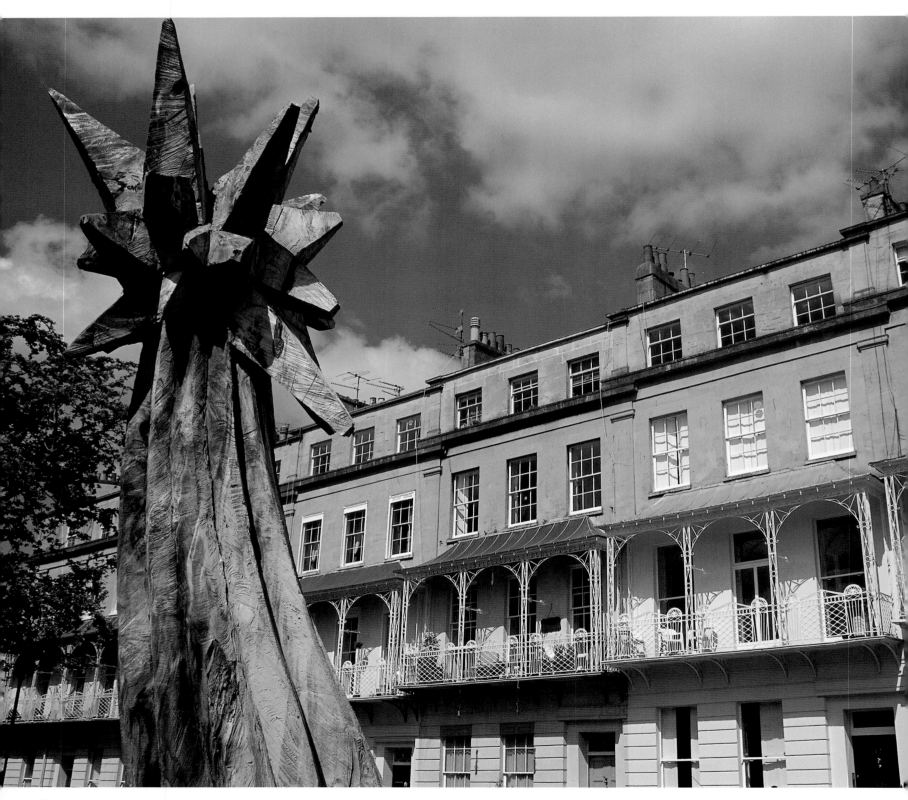

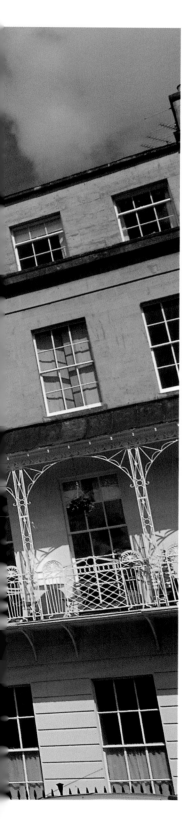

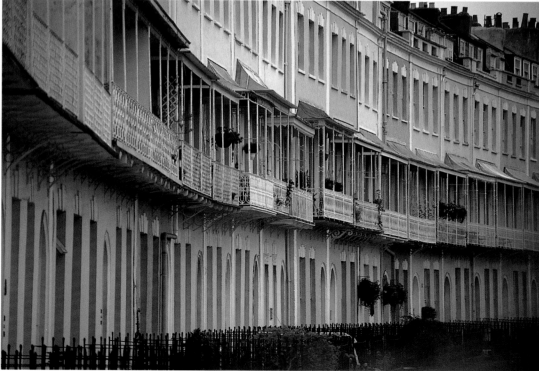

CLOCKWISE FROM LEFT
View-catching balconies on Caledonia Place, Sion Hill and Royal York Crescent.

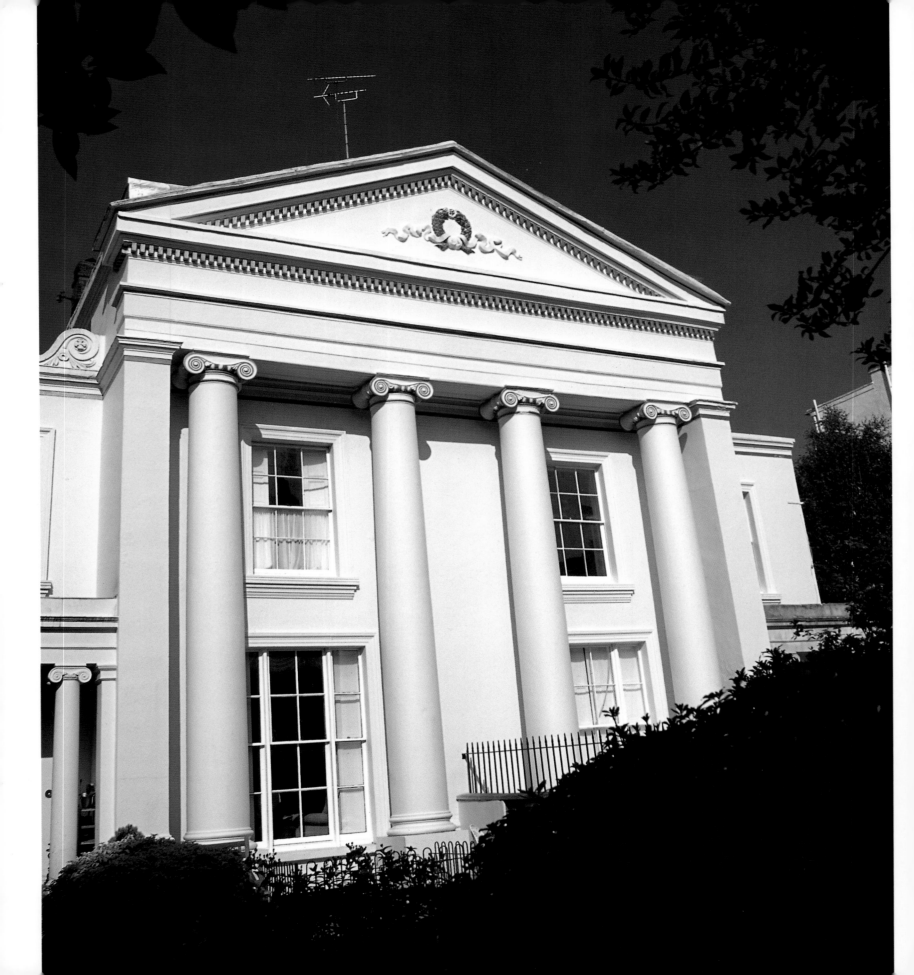

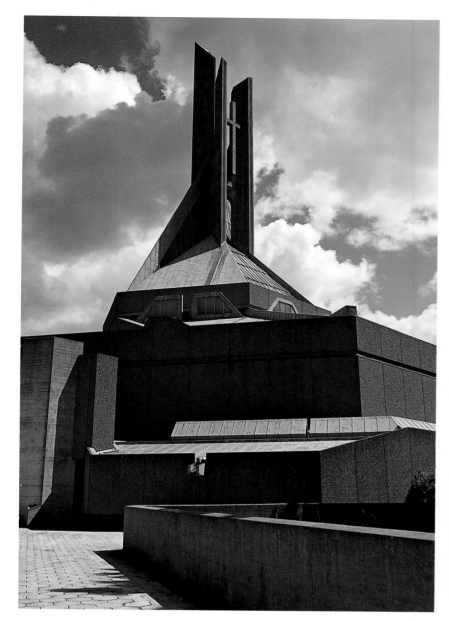

ABOVE LEFT **Brutalist symbolism** – Christ between the two thieves on the spire of Clifton Cathedral.

LEFT **Britain's most palatially elegant semi-detached house,** in Buckingham Vale.

ABOVE RIGHT **A failure of invention or cost-cutting?** The post-Blitz rebuilding of All Saints, Pembroke Road.

RIGHT **A New Cut bridge from Southville to Baltic Wharf,** with the terraces of Cliftonwood on the horizon.

RIGHT The Gothick gazebo at Goldney, which commands views over the Cumberland Basin, was once ringed by a colonnade of classical columns.

OPPOSITE ABOVE A river god presides over the source in Goldney Grotto – an escape fantasy for eighteenth-century Quaker ladies.

OPPOSITE BELOW LEFT Lilies on the formal canal at Goldney, dug in 1758.

OPPOSITE BELOW RIGHT Semi-precious quartz, known locally as 'Bristol diamonds', fuse with Caribbean shells in the vault of the Goldney Grotto.

BELOW A belligerent Hercules and a Gothick viewing tower in the gardens of Goldney House.

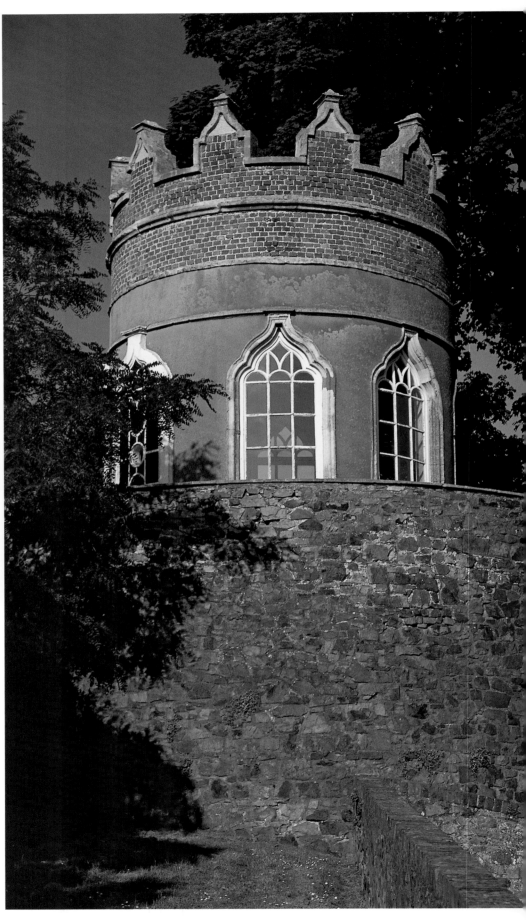

That is hardly a tithe of Clifton's extraordinary wealth. Tucked away in streets like Kensington Place and Richmond Park Road are exquisitely underplayed houses and terraces in that delicately incised neo-Greek architecture of the 1830–50 period which is Clifton's unique excellence. Add to that the Tibetan strangeness of the terraces strewn with such a shrewd feeling for the Picturesque sensibility on the cliff edges above the Avon, and we have Bristol's incomparable suburb – a city in its own right.

It would be reprehensible not to mention three relatively accessible tourist pleasures on the Clifton fringes. The gardens and the glittering crystal Grotto of Goldney House are a bizarrely beautiful and un-Quakerish creation of the 1740s, by devout Quaker ladies. Then there is the overwhelmingly rich woodwork and stone carving of the 1580s interiors of the Red Lodge, a garden banqueting house surviving from one of the great Elizabethan mansions on the quayside, where even

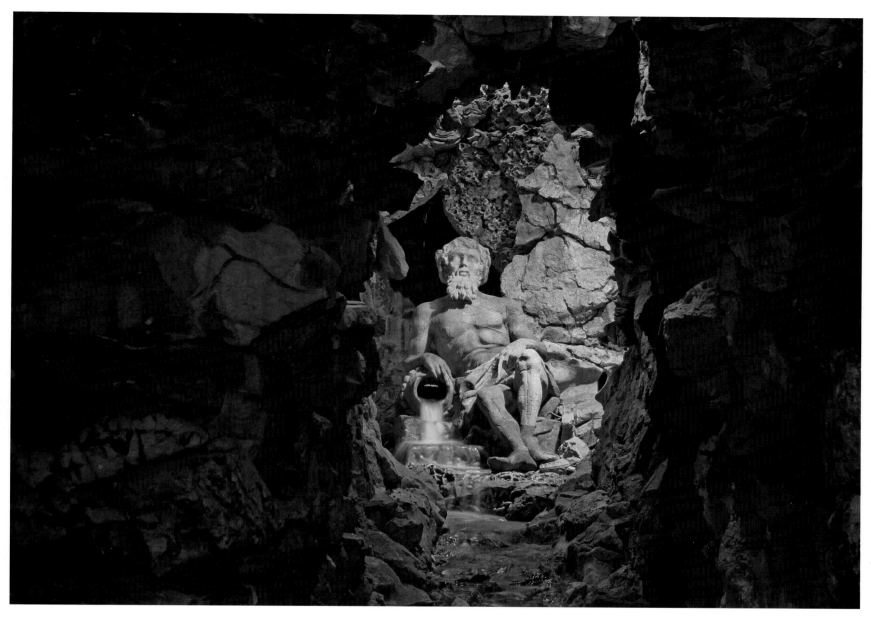

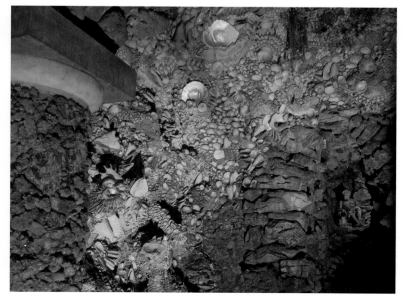

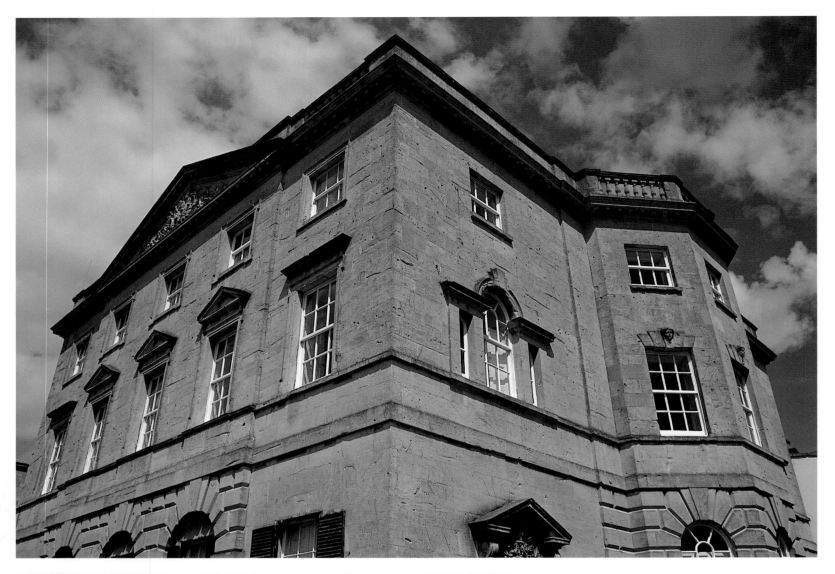

ABOVE The Palladian west front and the Rococo south front of the Royal Fort – a merchant villa designed by three architects.

LEFT The stairhall of the Royal Fort, with its serpentine balustrade and curvaceous feminine plasterwork commissioned by a woman.

ABOVE RIGHT John Hall's Elizabethan Red Lodge, once a garden house to his mansion, now has its own restored knot garden.

BELOW RIGHT A ribbed plasterwork ceiling in the Red Lodge.

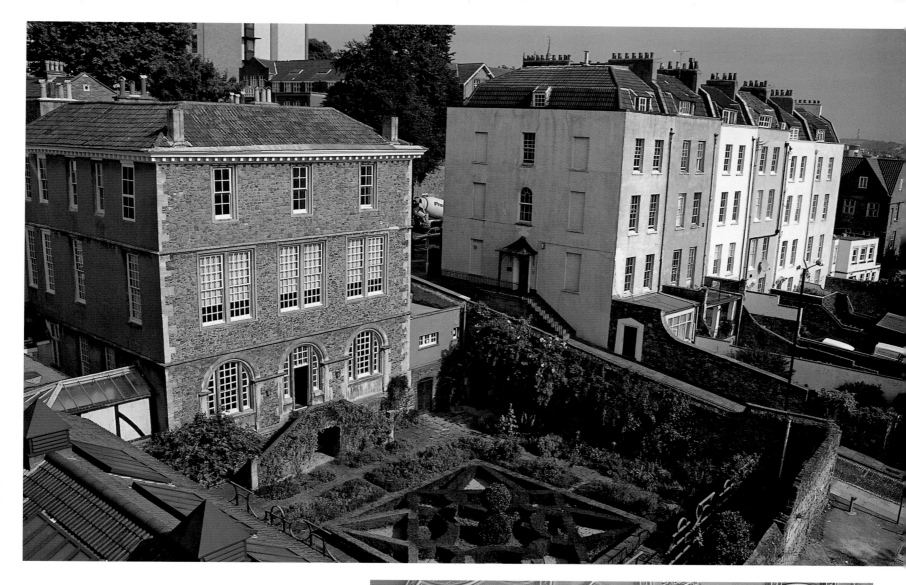

Red Indians feature in the intricacies of an interior porch. Lastly, and of more artistic importance probably than anything in Bristol, there are the Rococo interiors of the Royal Fort, a mid-Georgian villa of 1758–62, built on the site of a Civil War fortification at the western end of the King's Down. These exotic fantasy worlds are enclosed within a Bath stone exterior of three distinct classical styles – Baroque, Palladian and Rococo – put together at one period by three different local architects to the whim of a Quaker merchant's wife, Alicia Tyndall. If the Paty firm of builders – James, Thomas and William – who imposed so many dull brick Quaker elevations on Bristol, had done nothing but supervise the construction of the Royal Fort, creating the radiantly playful figurative plasterwork of the interiors, they would still deserve to be called Bristol's most significant artists, one of those rare English firms which was able to tear itself away from the tyranny of Palladio's predictable forms. No interiors in Bath come within measuring distance of the Fort's four brilliant interior spaces, its stairhall coming closer to the Rococo sublime than anywhere in this country.

alternative bristol

Much time could be spent arguing whether Clifton or Kingsdown was the more middle class in its social settlement. At a guess more householders in Kingsdown would read *The Independent* and more in Clifton would seek their political certainties in *The Daily Telegraph*, with *The Times* evenly distributed along both edges. Redland and Cotham, sandwiched between the two, is distinctly *Guardian*-reader land. Totterdown, on the outskirts, is interestingly different. Its seven streets of strictly two-storey, multicoloured bow-windowed dwellings went up in the 1850s as artisan, upper-working-class houses that clung, despite their Victorian date, to a residual Regency sensibility. Even now, though all its corner shops have succumbed to a Tesco Express, it has not shut down a single pub. Totterdown may have evolved into the most desirable 'starter' housing area in the city, but that artisan originality lingers on. There are even a few palm trees and banana bushes growing in those modest front gardens.

Looking down the cliff of brambles that rises above the main railway line out of Temple Meads station, Totterdown is a distinct socio-topographical edge, but most of Bristol's social edges have less visible boundaries. One of the most unexpected is yet another curving terrace, Avon House North. This, with its grey concrete elevations and machine-gun slit windows, bridges North Street and seems from its closeness to the sunken pit of St James Barton to be at the heart of a prosperous bustling Broadmead. But a walk under that graceless arch towards Stokes Croft takes the visitor into another country. The shops drop a gear in character, become more interesting and individual, but ever so slightly downmarket. If E.W. Godwin's masterful 1862 essay in the Bristol Byzantine style for Perry's Carriage Works were anywhere else it would have been snapped up for a smart restaurant and designer outlets; here on the social edge of Stokes Croft it languishes unused and the graffiti artists close in with their aesthetic demolition work.

RIGHT **Slanting light on the shops of Cotham Hill, scene of the infamous 'Curry Wars' of the 1990s.**

104

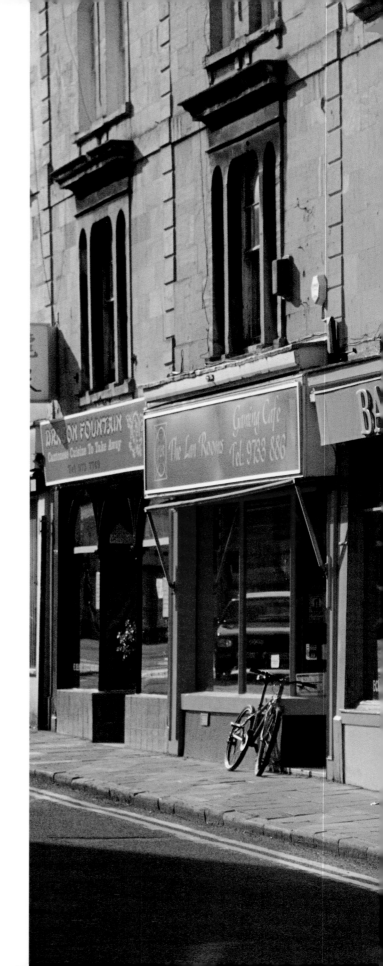

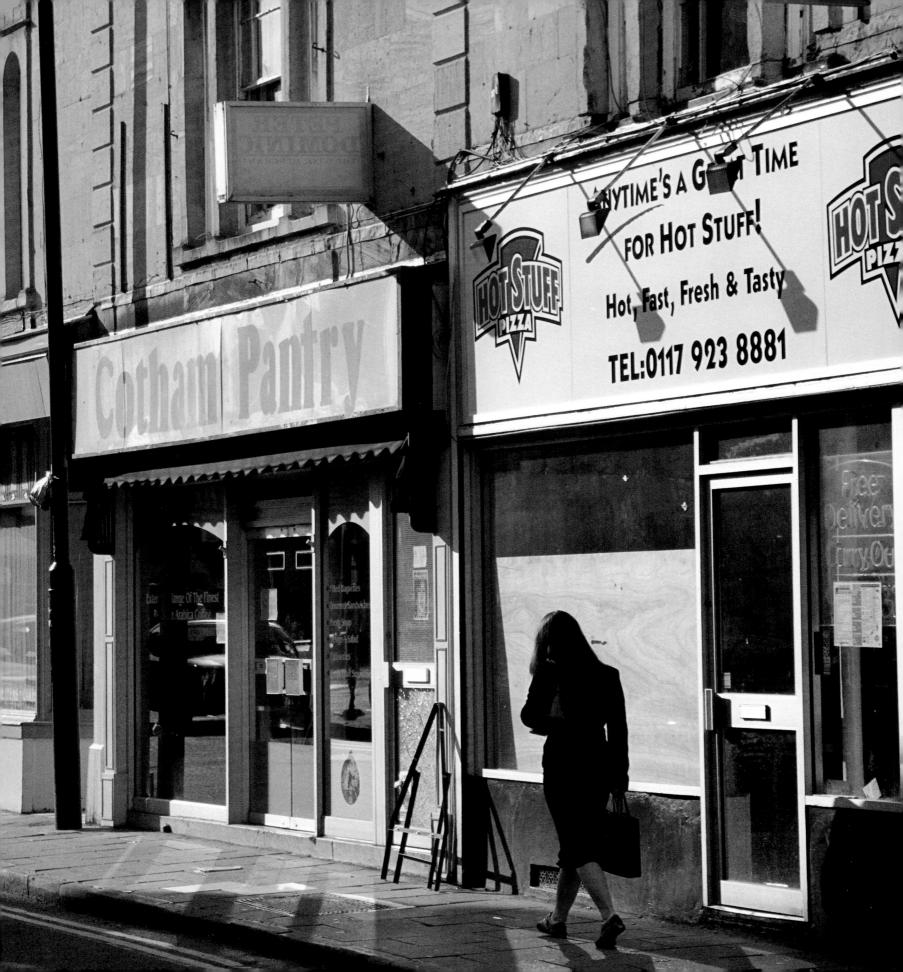

LEFT AND BELOW **A local corner shop closes and a female joinery workshop opens in hilly Totterdown on the Wells Road.**

ABOVE RIGHT **Bristol or San Francisco? Superior housing climbs a vertiginous hill at Totterdown.**

BELOW RIGHT **Literary textures in distress at Totterdown.**

BELOW FAR RIGHT **Bristol's noblest signpost – the Three Lamps – directs the way to sister cities.**

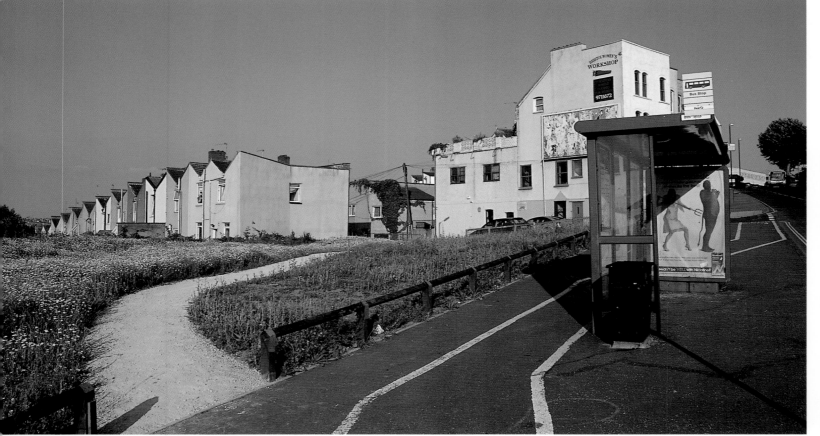

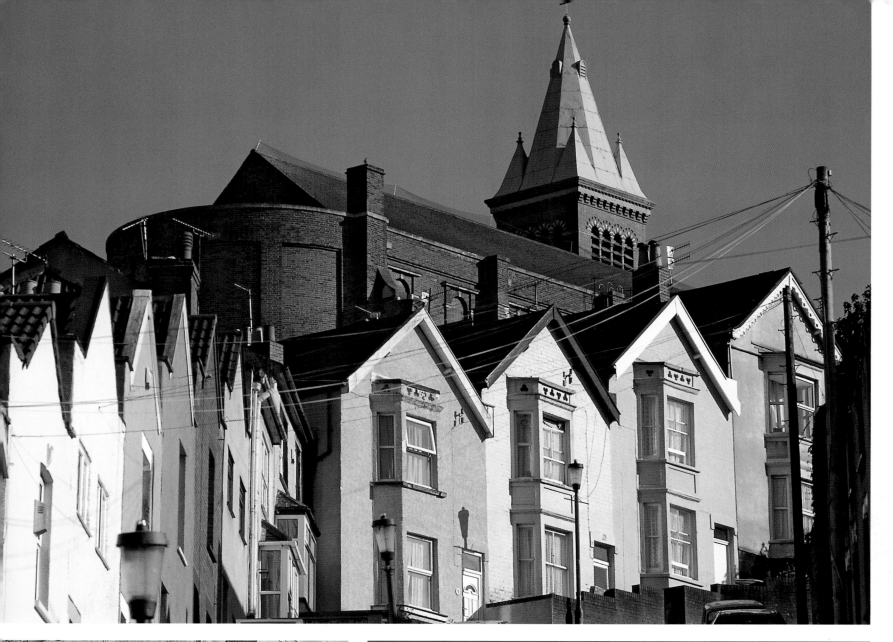

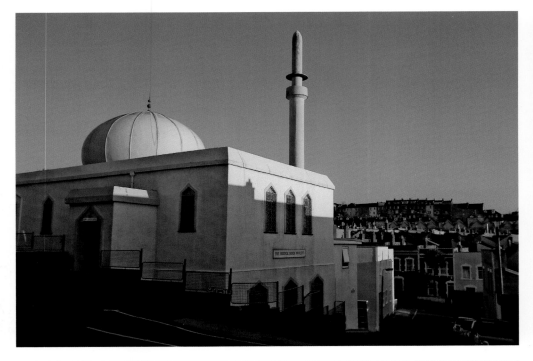

TOP **An new eclectic arrival in Windmill Hill.**

ABOVE **Urban blight in the recently proclaimed 'Gateway to the City' at Stokes Croft.**

RIGHT **Sixties office Brutalism reclad in 2001 as urban apartments for city professionals at St James Barton.**

BELOW The 1909 former
carriage works on Jamaica
Street was Bristol's first
experiment in exposed
iron-frame construction.

RIGHT St Paul's church has
been abandoned by its
congregation and now serves
as a circus school.

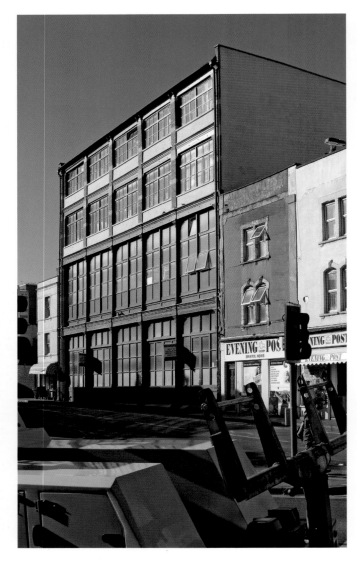

This eighteenth-century residential area tottered for a long time on the edge of dereliction. Twentieth-century prosperity came to the rescue almost too late, saving mere façades to house offices as the business quarter edged gingerly across Temple Way. The streets soon flow into St Paul's, the Afro-Caribbean sector of Bristol with its lively record of carnival, minor riots and guarded glances. Among the uncertain patches of red brick flats and light industry there are, on Ashley Road for instance, better 1780s terraces of linked semi-detached houses than Clifton can offer. Picton Street has a real tension of exotic grocery shops, Italian delicatessen, bijoux Regency villas and a touch of Soho's extra-curricula activities. That is because Montpelier, Bristol's most louche and nervously characterful suburb, is rising here on its hillside up above this Caribbean St Paul's. There are streets around here where

RIGHT Twentieth-century
artist and Victorian architect
in romantic collision on
Stokes Croft.

FAR RIGHT Allotment
Elysium in the Mina Valley,
with St Werburgh's church
in the distance.

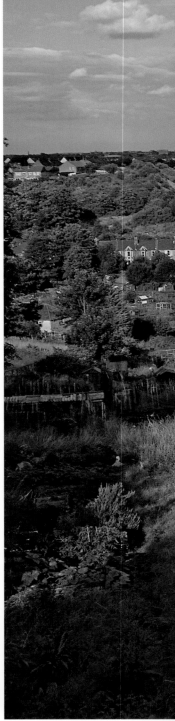

Banksy, the shy Leonardo of stencil graffiti artists, stalks at night, leaving art of a political kind, as teddy bears throw Molotov cocktails at policemen in The Mild Wild West. Montpelier railway station is entirely covered in graffiti. Tall, gently wrecked 1820s houses tempt the braver house-buyers with bargain prices, and Fairfield School, where Cary Grant was educated, rears its terracotta Queen Anne Revival elevations in the middle of streets which it is tempting, though inaccurate,

to call 'mean'. Montpelier actually smells different from Bristol, with delicious wafts of freshly baked bread from Herbert's Bakery just off Picton Street.

Most edges lie on hillsides, like Totterdown and Montpelier, but the next Bristol edge is perversely sunken. Below Ashley Down and between the two railways lines, one to Severn Beach, one to Gloucester, lies the Mina Valley, home to the elite opt-outs of the whimsical political left. Even its street names –

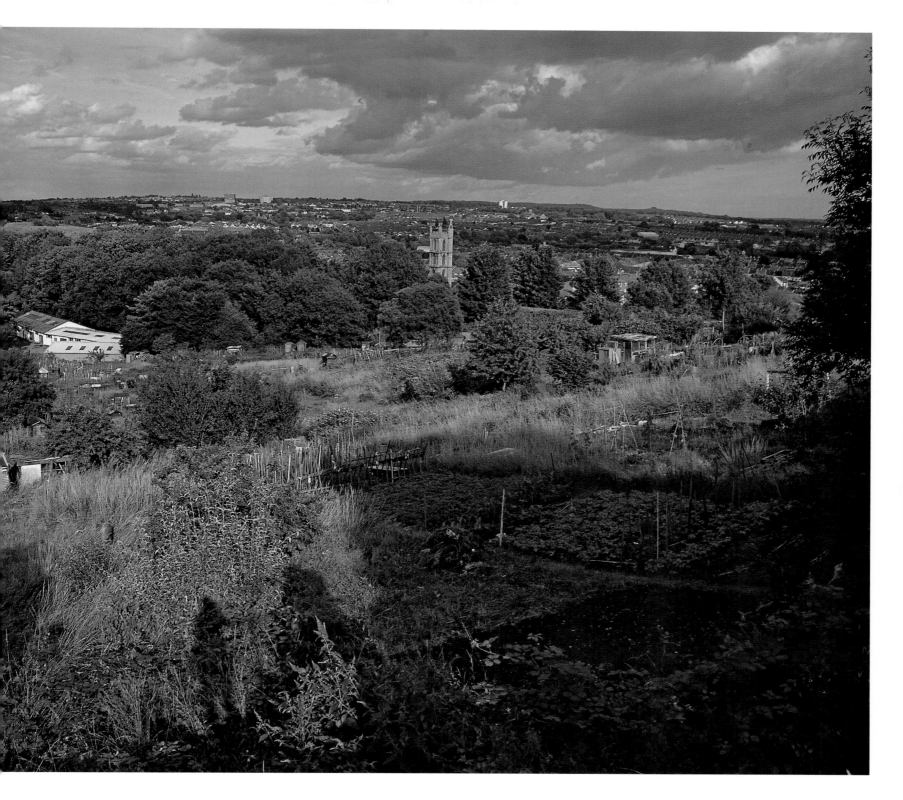

Watercress Road and Boiling Wells Lane – spell a fey enchantment. It opens with a mock medieval shopping precinct on Mina Road where signs hang out over every shop to announce its trade with wit: a newspaper where in the headlines on the front page UFOs are sighted over Bristol, and on the back, England has inexplicably beaten Brazil 3.1, a huge silver fish, a giant saw. Then, after St Werburgh's church, whose tower was once sited on Corn Street in the Old City, but which has been rebuilt here and serves with its nave as a mountain climbing centre, comes a symbolic tunnel under the railway to mark another edge line and all the delightfully tatty slopes of the Valley. These are allotment-ridden, with bean rows, old men's refuge sheds, an adit from a long-lost coalmine and the spotted pigs and lecherous-looking goats of St Werburgh's City Farm.

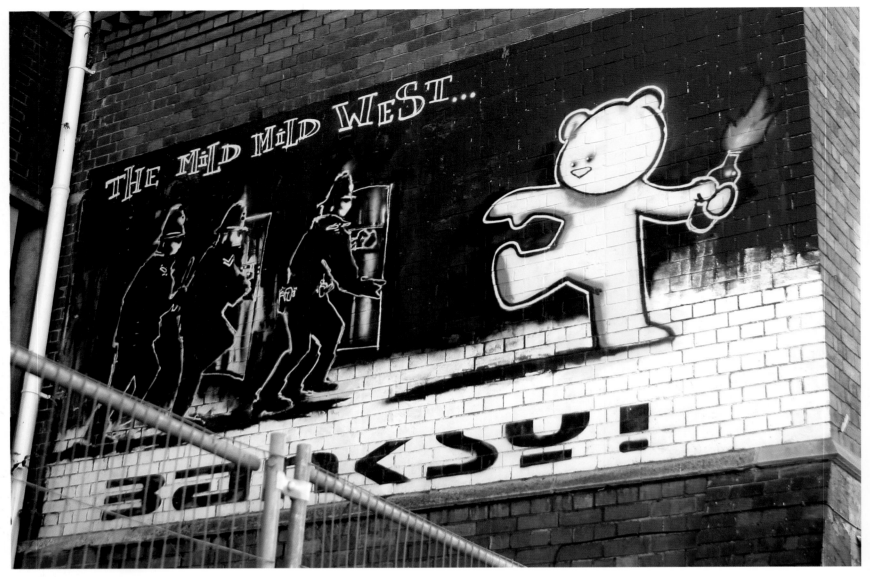

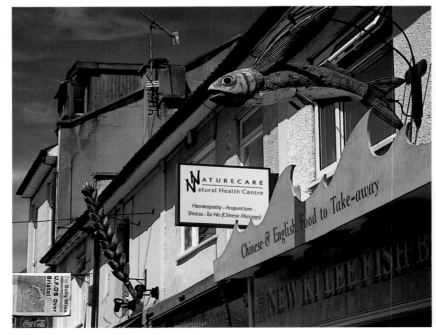

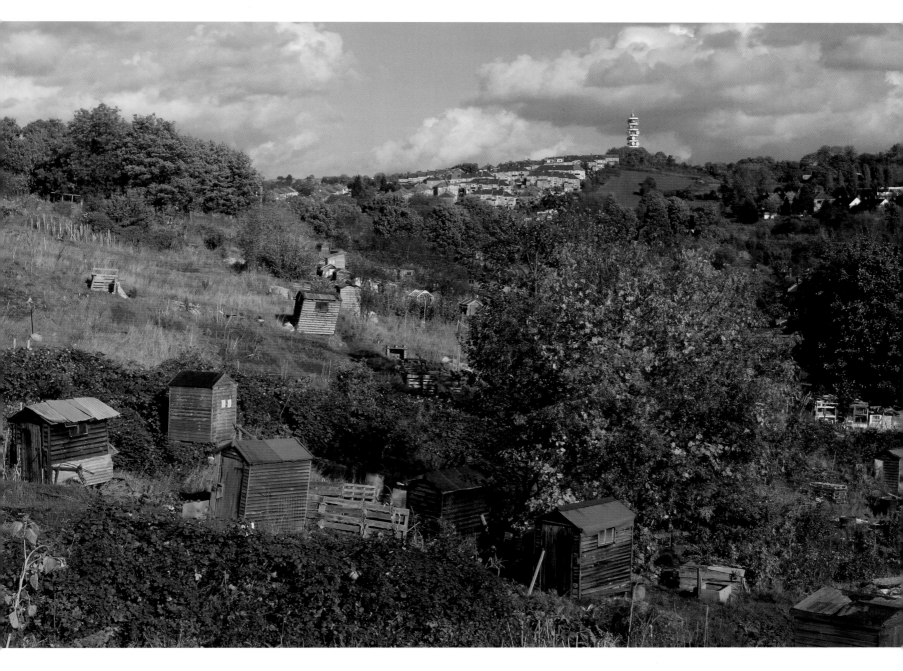

The crescendo of alternative living is yet to come. Twenty years ago Graham Caine and Martin Muller designed one weird but undeniably beautiful 'gnome house' as they call it, and one equally extraordinary café behind the Farm in a style that is half mad Gaudi Art Nouveau and half Roger Dean 1970s fantasy LP record cover. Their walls twist and twine like living growths. It was inevitable that they would inspire others to protest against uniformity and that is what has happened. In a bizarre remembrance of John Nash's Hamlet, the model village for the Blaise Castle Estate at Henbury, a group of independently minded people formed the Ashley Vale Action Group Limited and bought a Hamlet-sized plot of land off Boiling Wells Lane. There, in a circle of chemical colours and unpredictable out-lines of wood, plaster and tile, each member has built his or her own house to an entirely original design.

There seem to be thirteen of them, but perhaps, like the stones of Stonehenge, no one can accurately count them. Each one is its builder-owner's dream come true, with sun balconies, projecting studies and infant-friendly nurseries. Rather sadly, all are Nordically angular. Not one has picked up on the sinuosities of the 'gnome house' and café. Unfinished as they are, they are still in their prime because, like Nash's Hamlet, they are ranged around an open area and looking their Joseph's coat of many colours best. Economy apparently demands that more houses will soon cover the central space, which is a shame, but the money of a banker like John Scandrett Harford would be needed to afford the luxury of a village green as in Blaise Hamlet.

ABOVE **The Mina Valley, where alternative oldies retire to meditate upon the swinging sixties.**

OPPOSITE ABOVE **Banksy strikes again – the** *Guardian*'s **favourite artist of whimsical protest.**

OPPOSITE BELOW **Traditional shop signs on the refurbished Mina Road, St Werburgh's.**

the outer fringes: idyllic west and demonic east

As the second largest and richest city of the kingdom for long periods over the last thousand years Bristol has, naturally developed a surrounding chain of architectural treasures, its modest equivalents of London's Hampton Court, Windsor Castle, Kenwood House and Syon Park. Far out to the north of the city are Iron Acton, a gaunt Tudor hulk where King Henry VIII and Queen Anne Boleyn frolicked briefly in 1535, and there are the relics of the earliest Renaissance garden in Britain at Horton Court, created for one of Henry's Italian-travelled ambassadors. But the real inner ring lies within a mile of the city's limits and has a distinct west–east bias. To the west are the pleasure houses in idyllic hilly country, refreshed by sea breezes; east Bristol was the industrial heartland of the brass smelters with fume, slag, waste tips and sudden bankruptcies.

Nothing points the contrast between the two areas better than the difference in essential character between two Gothick folly castles which should, by their form and date of building, be similar. Out in the west, Blaise Castle House is a bland classical villa set in one corner of Humphry Repton's ingeniously deceiving landscape, where a long dramatic carriage drive was devised to give the impression of a very large park by diving down into, and laboriously out of, a romantically wooded ravine before reaching the house, which is actually sited on the edge of Henbury, a commuter village. Repton had been commissioned to prepare a 'Red Book' of the proposed improvements in 1795, not by an industrial magnate, but by a rich Quaker banker, John Scandrett Harford. The 'castle', which gave the estate its name, was an enchantingly picturesque trefoil of Gothick turrets which had been built in 1766 by an earlier owner, Thomas Farr, to conceal an unsuccessful pumping station and provide a viewing tower. The only fumes it ever gave off were those of fireworks and canon fired to create a romantic echo.

RIGHT **Blaise Castle of 1766,** the destination for a failed expedition of Jane Austen's heroine Catherine Morland in *Northanger Abbey*.

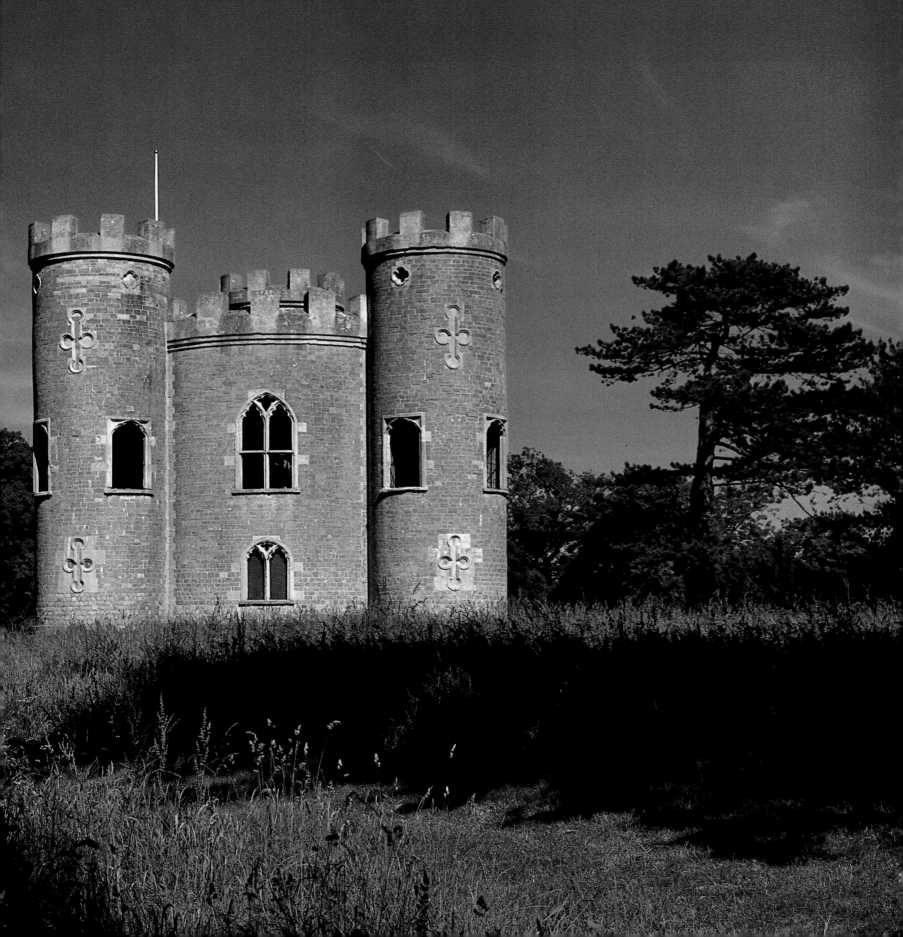

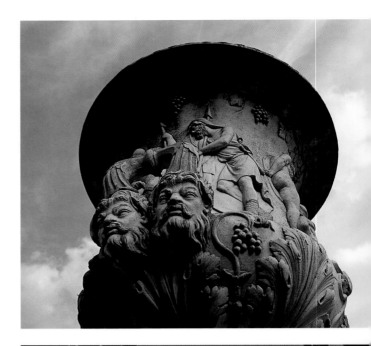

These inviting wooded slopes around Henbury retain the tradition of leisure and alfresco pleasure, but now the stylistic note, while still every bit as whimsical as the Gothick, has moved on to Ian Hamilton Finlay's intellectual game of inscribing half-comprehensible quotations across each and every available surface. The field below the castle has become a playground, where harassed parents can not only leave their children to enjoy a maze of swings, slides and fantasy climbing frames, but take coffee or ice cream in a spanking new glass and aluminium café opened in March 2005. Exquisitely inscribed upon the café's glass wall is a yearning fragment of poetry: 'And Years Afterwards You'll Remember That Kiss On The Bridge Where Nail Heads Glittered Like Stars Under Your Feet'. First we had, by Finlay's inspiration, Poems on the Underground; now we have Poems on the Playground. There are more poems by Fiona Hamilton around the corner where the Punch and Judy plays:

> I Have A Fancy For A Gothick Castle On A Hill
> Views Of A Pleasure Ground Dancing Waterfalls And
> Streams
> It Must Appear A Love Affair Between Nature And Art

Of one thing we can be certain. Humphry Repton, that precious wretch, would have entirely approved. Life must be getting better, must it not?

The Black Castle down in the Avon valley at Brislington just east of Totterdown is similar in form but has inspired no poetry. It is indeed quite demonic in impact. Horace Walpole called it the Devil's Cathedral. The rich, violent Quaker brass founder William Reeve, who had built it in 1764, was Harford's absolute opposite. His house, first named Mount Pleasant and latterly Arno's Court, is no banal classical box like Blaise Castle House. A defiant Gothick skin has been thrown over a normal canted-

LEFT **This overwrought urn on the terrace at Blaise Castle accords oddly with the stark simplicity of the villa.**

RIGHT **Gnomic glass engraving at the Blaise Castle estate café.**

BELOW **John Nash's brilliant picturesque free-form housing at Blaise Hamlet, an anticipation of the later garden cities.**

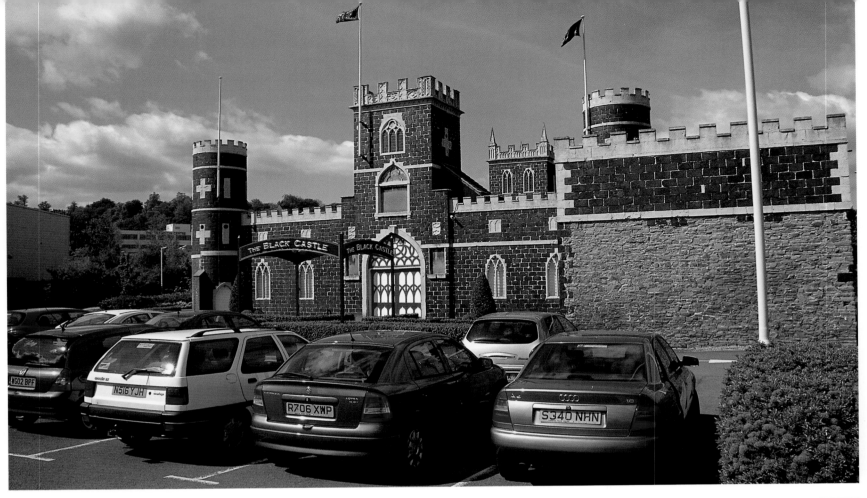

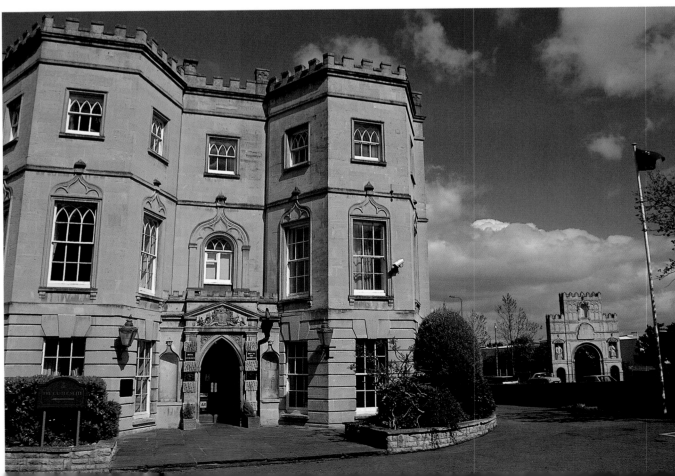

bay villa and inside pheasants and ho-ho birds of plaster fly on the dining room ceiling. For his administrative block and entertainment centre, Reeve used the iron-hard, jet-black blocks of slag from his brass works up the Avon at Crew's Hole to create a bizarre polychromatic castle of four towers with a central courtyard. Grotesque figures on the walls suggest that he employed William Halfpenny, an eccentric pattern-book architect, to design the memorably ugly castle; it was constructed, inevitably, by the Patys. Today it stands uneasily next to a giant Sainsburys store and a garage. William Champion, a fellow Quaker whose copper and spelter foundry lay two miles up the Avon at Warmley, fell into the same sinister line of Gothick design in the back garden of his dimly elegant classical house. He created, using the same black slag, an Echo Pond, a black grotto of clinkers with a monster's mouth opening, and oddest of all, a twenty-foot-high statue of Neptune, the Warmley Giant, naked except for a loin cloth of black clinker. Once Neptune stood on an island in a lake; now it glares back at a huddle of

static homes in their park. The Quakers of Bristol have a suspect record of aesthetic patronage.

These picturesque Gothick ventures were the experimental work of short-lived Quaker dynasties, eccentric buildings from eccentric non-conformists, in no way mainstream stylistically, but then Bristol has rarely been mainstream in its architecture. There were, around the outskirts of the city, a few houses of more establishment local landowners, but even from these the stylistic directions were uncertain. The Stafford Duke of Buckingham was shaping up to become locally dominant in Henry VIII's early reign, turning his seat of Thornbury Castle into a sophisticated, multi-towered Tudor palace. Its grandeur was Buckingham's undoing. The King coveted Thornbury and, since Buckingham's claim to the throne was a good as his own, he executed the Duke on a trumped-up charge, ending any chance of Thornbury becoming an influence on Bristol building. The castle remains a splendid ghost of high walls shielding an hotel.

ABOVE LEFT William Champion's naughty giant Neptune with a slag jockstrap at Warmley.

ABOVE RIGHT In strange juxtaposition to Neptune – Warmley's static home park.

OPPOSITE ABOVE Brislington's Black Castle under siege by car parks and a massive Sainsburys shed.

OPPOSITE BELOW A perfect instance of mid-Georgian Rococo Gothick at Arno's Court.

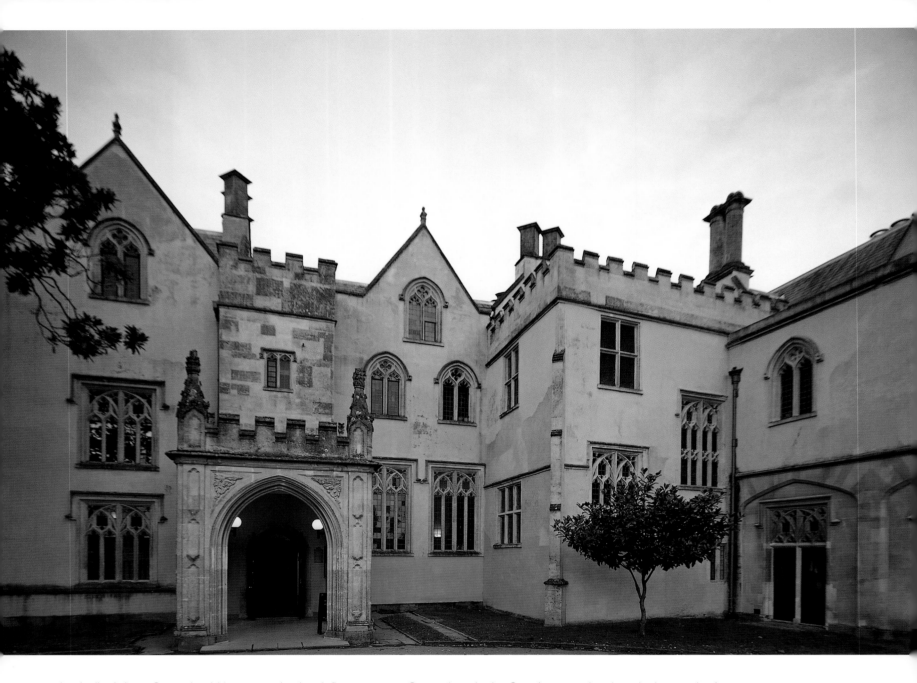

Logically, Ashton Court should have exercised an influence upon the city which it overlooks from its beautiful deer park. The Smyth family of Ashton should, by their wealth and land holdings, have become earls at the very least, yet their line petered out in 1946 with them still untitled. Their Court is typical of Bristol's stylistic confusion. It is an enormous house, rambling along its hillside in a jumble of varying styles, its many façades like an ill-shunted train. Inigo Jones himself may have given Thomas Smyth a dashingly fashionable classical design for the main house but, as Windsor Terrace in Clifton demonstrates, a local Bristol builder can massacre any professional design. Inigo's elevation, if it was his, stands awkwardly next to a conventional sixteenth-century gatehouse and his correctly pedimented windows have been most incorrectly sited on the façade in order to fit them to the existing rooms behind.

Somewhere in the Court's many chambers is the wreck of a beautiful Gothick Library of 1767 awaiting restoration; but in fairness to the City Council who own it, the Court is not an easy house to love. Another unsatisfactory 'stately home' presides over the M32 from a commanding wooded hill-top in Stoke Park. The local squire responsible for its odd, battlemented, canted-bay towers was Norborne Berkeley, an unpredictable bachelor who stowed away on a British expeditionary force to St Malo in order to gain military glory. His equally unpredictable friend and architectural adviser, Thomas Wright, the 'Wizard of Durham', persuaded him to choose an indeterminate Gothick style to front his sixteenth-century manor and the present developers of the estate have painted Wright's elevations a mustard yellow – no stylistic guidance there for Bristol. After raising his mock medieval castle Norborne Berkeley lost all his

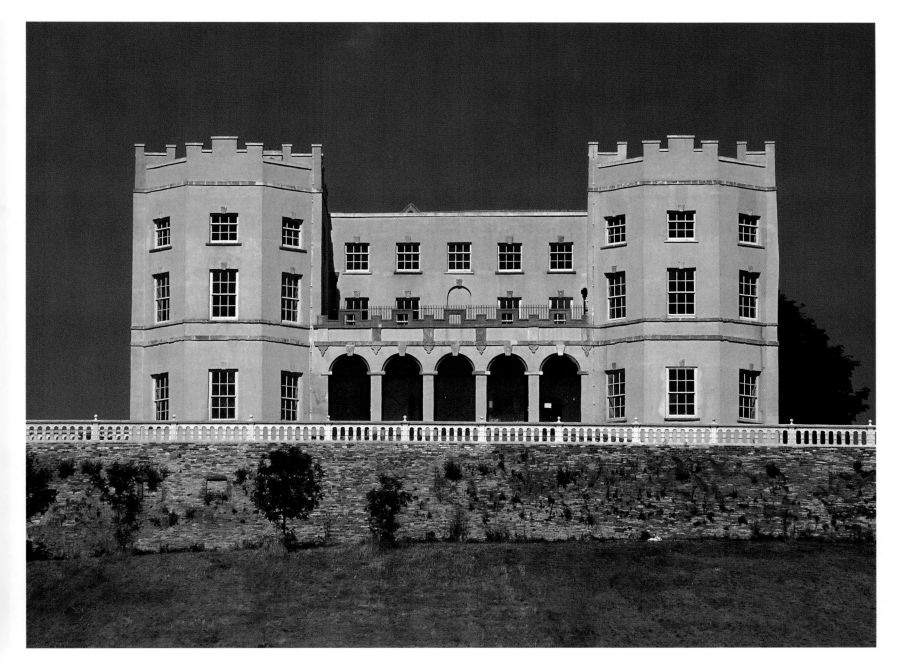

money when Champion's Warmley brass works failed and he retreated to America to become Governor of Virginia.

In a satisfying parable of contrasting patronage the banker J.S. Harford built no numinous Gothick structures to accord with his inherited Blaise Castle. Instead he employed John Nash to create, around a delicately contoured village green, a hamlet of imaginatively picturesque cottages as a retirement reward for his ex-employees. Built in 1809–11 with a village pump and sundial as its central feature, Nash's hamlet of nine cottages is as dreamlike and removed from real life today as it was when it was first occupied. Here time really does stand still. Each cottage works like an intricate touch form of bows and recesses with outdoor seats designed to encourage sociability and gossip. Tall Elizabethan-style chimney-stacks produce a connecting motif to pull their gnome-like complexities

together and two lines of dovecotes face each other in gable ends across the green.

As its counter to the bucolic charms of the Hamlet, the east side of the city offers Arno's Vale Cemetery, quite possibly the most Arcadian graveyard in Britain. The tombs lie in among mature woods between Totterdown and William Reeve's Arno's Court in Brislington. Two pure Greek Doric lodges guard its entrance. They are by Charles Underwood, built between 1837 and 1840, perfect guardians in their austerity to the ghosts of the dead. Inside the cemetery is an Anglican funerary chapel, partly vandalized and dark with ivy, but as hauntingly numinous as some Roman mausoleum on the Appian Way; Charles Dyer is its most likely architect.

The one truly impressive, even great, house in this inner sequence is Kings Weston, where the architect was Sir John

OPPOSITE **Architectural confusion at Ashton Court.**

ABOVE **No such uncertainties plagued the developers at Stoke Park, Bristol's sentinel Georgian castle overlooking the M32.**

Vanbrugh, working between 1710 and 1719 for Sir Edward Southwell. The result was a brooding giant of a house where conventional classical details have been dramatized into a staid, rather than a moving, Baroque composition. With its several ambitious garden buildings the house was designed to command a vast view of estuaries and shipping; now it looks out over the smoke stacks of Avonmouth and the ceaseless movements on the M5 motorway. Bristol generally seems uncertain what to do with its great houses, and the park around Kings Weston is attractively overgrown and melancholy, perfectly in tune with its parent house. The sadness about Vanbrugh's design was that it was achieved just as the Baroque became old-fashioned, so it could hardly serve as a model to the city since his elevations parody the newly emerging Palladian Revival rather than exemplify it.

Only one building in the city seems to have taken its chunky individuality from Vanbrugh's Kings Weston and that is the Redland Chapel. It was begun in 1740 by a Scottish architect, John Strahan, and completed by William Halfpenny; consequently there is nothing else quite like it in the country. Instead of a tower it has a gadrooned dome that seems to be held down to the octagon beneath it, a composition more sculptural than architectural. It all sits perched uneasily over a

narrow, but heavy, entrance front, Kings Weston in its feeling. Inside the chapel is pure theatre. The gallery has the best seats and John and Martha Cossins of Redland Court, who paid for the chapel, have been carved by J.M. Rysbrack to play forever the part of silent audience from their niches. The nave is curiously pervaded by serious, dimpled cherubs, works of the Paty firm, carved along the guilloche frieze of the wainscoting. Dominating the space is the proscenium arch to the sanctuary, rich with Thomas Paty's limewood carvings. The altar table is uniquely secular, supported by lovely winged and full-breasted harpies which have to be covered with a cloth during services. Above them is a curtain of stucco work being raised by the hand of an angel to reveal a painted Glory. When a patron like John Cossins was able to overrule the hesitations of Protestant clergy the Baroque could deliver a wonderfully moving interior.

The exterior of the chapel is more revealing than moving: revealing of the quite shameless confidence of eighteenth-century Bristol gentry and investors as to the rightness of the infamous three-cornered slave trade. Carved on the wall of the east end are two perfectly contented blackamoors, not gestures of protest, but simple reminders of how Bristol made the money to pay for so much handsome architecture.

RIGHT Halfpenny and
Strahan's Redland Chapel is a
cheerful parody of Vanbrugh.

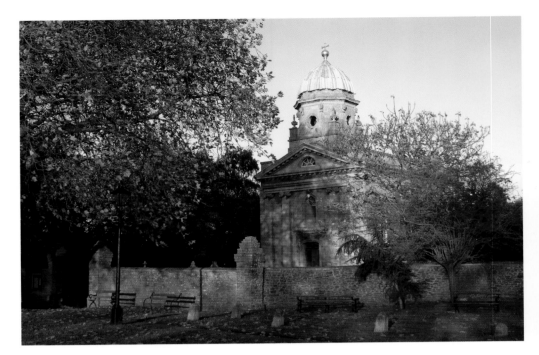

BELOW The stylistically
schizoid east front of Kings
Weston – three variants of the
classical Venetian motif in the
centre topped by a range of
castellated mock medieval
chimneys.

index

Note: Page numbers in *italic* refer to the captions to the illustrations. Page spans in **bold** print include illustrations between those page numbers.

acknowledgments

I owe a debt of gratitude to several writers on Bristol for their insight and their erudition – Mike Jenner on architecture, John Punter on planning, Peter Aughton on social history and Douglas Merritt on sculpture – and particularly to my former student Andy Foyle, whose recent *Pevsner Architectural Guide* to the city has been invaluable. Finally I must thank my friend and collaborator on architectural studies Brian Earnshaw, for his judicious editing of the text and for his help with the captions.

 Tim Mowl,
 Bristol, May 2006